Christian VIII
The National Museum

Christian VIII

The National Museum

THE NATIONAL MUSEUM OF DENMARK

Christian VIII and the National Museum

© The National Museum of Denmark and the authors. Copenhagen 2000
Editors: *Bodil Bundgaard Rasmussen, Jørgen Steen Jensen* and *John Lund*.
Design and Production: *Freddy Pedersen*
Typeset with Linotype Bembo and printed on Galleri Art Silk.

ISBN 87-89438-05-1

Photos: *Niels Elswing, Lennart Larsen, Kit Weiss* and *Henrik Wichmann*.

The following museums kindly provided photographs:
*Frederiksborg Castle, The Hirschsprung Collection, Jægerspris Castle,
The Royal Museum of Art, Thorvaldsen's Museum*

Published with financial support from:

*Advokat Axel Ernst's og frøken Alfrida Ernst's Legat til Fremme
af Numismatisk Forskning i Danmark.*
Generalkonsul Gösta Enboms Fond
Landsdommer V. Gieses Legat
Krista og Viggo Petersens Fond
Grosserer E. Schous Legat

Contents

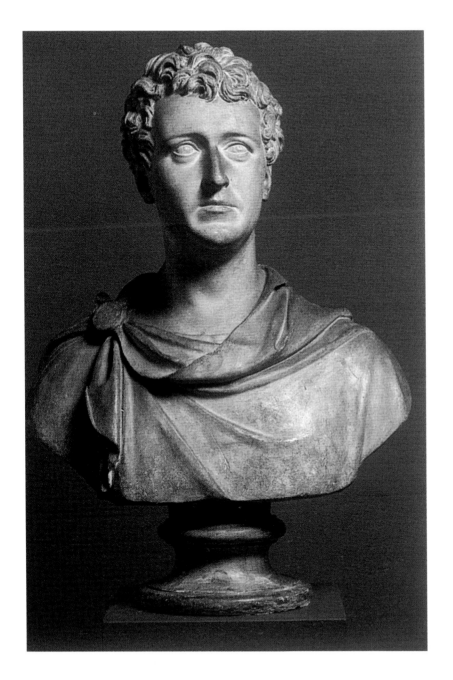

Prince Christian Frederik. Portrait bust by Bertel Thorvaldsen made in Rome in 1821. Thorvaldsen's Museum.

Preface

Been in the Vase Cabinet – is a remark that frequently occurs in the 1821–1839 diaries of Prince Christian Frederik of Denmark. The Prince, born in 1786 did not succeed to the throne of his country until 1839. This circumstance left him ample time to pursue his various interests and build up several collections. As president of the Royal Academy of Fine Arts from 1808, the Prince was active in learned and artistic circles.

In 1813 he became a diligent governor of Norway, but the terms of the peace of Kilonia (Kiel) in 1814 forced Frederik VI to surrender Norway to Sweden. The Norwegians, however, took matters into their own hands, gave themselves a free constitution and elected Prince Christian Frederik as their king. After a short war with Sweden, peace was negotiated on the understanding that the Swedes respect the Norwegian constitution and the Prince return to Denmark. The Norwegian experience implied that Danish liberal circles expected him to initiate far-reaching reforms when he became king. This was not to be though and Christian Frederik – as Christian VIII – lived and died the last absolute monarch of Denmark.

In 1816 the Prince had married Princess Caroline Amalie of Augustenborg, as his second wife, and together they made a grand tour of Europe taking in Germany, Switzerland, Italy, England and France from 1818 to 1822. Italy was of special importance for the Prince who, when in Naples in 1820, acquired a collection of antiquities that was to become the core of the later Vase Cabinet. He was also keenly interested in ancient coins and made detailed studies of mineral collections, acquiring both coins and minerals for the collections that he had started as a boy.

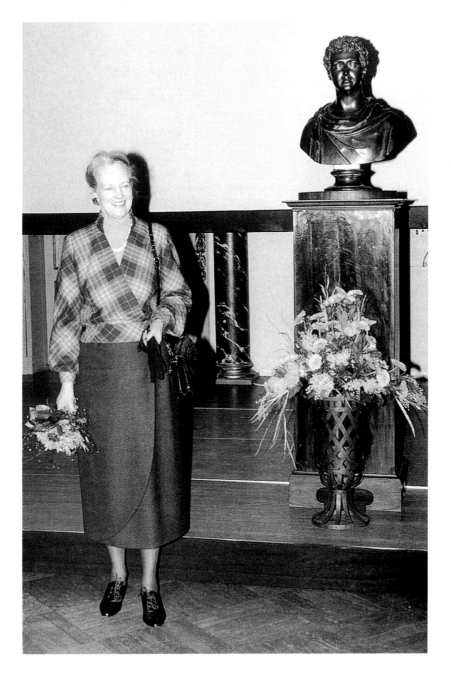

*Her Majesty Queen
Margrethe of Denmark
attending the symposi-
um on Christian VIII
and the National
Museum. Thorvaldsen's
bust of Christian VIII,
standing on one of the
King's coin cabinets, can
be seen in the back-
ground.*

After Christian Frederik succeeded to the throne of Denmark in 1839, he had less time to spend on his collections. However, with the help of several of the eminent scholars of the time, Peter Oluf Brøndsted, Christian Tuxen Falbe and Christian Jürgensen Thomsen, the collections were continuously augmented and improved.

Christian VIII died at Amalienborg Palace on January 20th, 1848. Some days before, his bed had been moved into the Vase Cabinet, and here he spent his last hours among the cabinets displaying Greek vases and the cupboards filled with ancient coins and revolution medals. Some years after the King's death his antiquities were taken over by the Danish state and today they constitute the core of two collections of the National Museum: The Collection of Classical and Near Eastern Antiquities and the Royal Collection of Coins and Medals.

It was appropriate that the Museum should mark the fact that January 20th, 1998, was the 150th anniversary of the King's death by holding a symposium entitled *Christian VIII and the National Museum. Antiquities – Coins – Medals.* Contributions dealt with the King as collector and the significance of his collections for the Museum of today. The present publication contains the somewhat reworked papers given at this symposium, translated into English by Jennifer Paris-Dupuis.

The editors offer their sincere thanks to the several foundations that made it possible to publish this edition of the symposium papers. Last but not least we thank Professor Ted Buttrey, The Fitzwilliam Museum, Cambridge, for his generous help and advice.

Bodil Bundgaard Rasmussen
Jørgen Steen Jensen
John Lund

A Danish Prince in Naples

Bodil Bundgaard Rasmussen

In 1986 a Greek amphora returned to the National Museum in Copenhagen after a journey that had taken it across the Atlantic, across the North American continent, and back again. This black-figure amphora, decorated by the so-called Amasis Painter, had been on show at an exhibition entitled *The Amasis Painter and his World* (in New York, Toledo and Los Angeles).[1] The exhibition comprised 65 of the 132 known vases attributed to the Amasis Painter, one of the most important of the Athenian vase painters in the sixth century BC. The exhibits had been borrowed from museums and private collections in Europe and in the United States, and the catalogue was the work of one of the greatest experts on the production of this painter, Dr Dietrich von Bothmer[2] head of the Department of Greek and Roman Art at the Metropolitan Museum of Art. The Ny Carlsberg Foundation had made it possible for the vase to be shown in the exhibition because this foundation had, in fact, donated it to the National Museum in 1968; however, taking a broader-based view, it was also made possible by Prince Christian Frederik of Denmark (later King Christian VIII), whose residence in Naples in 1820 led to the establishment of a collection of ancient pottery in his native country. His "Vase Cabinet" became a collection of very high standard, and it has been a pleasure for posterity to augment it – for example, by the inclusion of the Amasis Painter's amphora (fig. 1). But how did a Danish prince acquire such an interest in Greek vases that, while visiting Naples, he laid the foundations of a Vase Cabinet? To find an explanation, we must go back to the Prince's earliest youth when Niels Iversen Schow, a professor of philology, was his teacher. The learned professor took the young Prince on visits to the Kunstkammer and gave him an insight into classical Antiquity. The Prince became fascinated with this subject, writing in

Fig. 1.
The scene on the amphora painted by the Amasis Painter. The goddess Athena and four men. 550-530 BC. (Inv.no. 14347)

his diary in 1803, when sixteen years old: *I must also improve my knowledge of Roman and Greek history.*[3] Schow's tuition and the Prince's own interest in Antiquity did in fact prepare him extremely well for his later grand tour, which was to take him to Naples, one of the cultural centres of Europe at that time. Neither should it be forgotten that the Prince had proved himself a keen collector at an early age. Already in the 1790s he had had his own collection of coins.[4]

Prince Christian Frederik and his wife Princess Caroline Amalie began their grand tour in 1818, spending time in Germany before reaching Rome on December 23rd, 1819. The newly-appointed Royal Agent in this city, P. O. Brøndsted, an archaeologist, immediately paid his respects to the royal couple. The Prince had become acquainted with Brøndsted already in 1813 when the latter had returned to Denmark after several years in Greece. On his return Brøndsted had written as follows to the Prince: *At last returned to my fatherland, I am deeply sorry not to fulfil my hope, that immediately on my homecoming, I should be able to approach a Prince, whose love of and benevolent care for the arts and the sciences and the noblest achievements of the human spirit, have become well known to me, and to*

whom, through my knowledge of Greece and Italy, I might perhaps bring some news which, when discussed with a noble and influential protector, could well prove fruitful and profitable.[5] The Prince's reply does show a genuine interest in the arts and sciences. The following is an extract from his letter: *Already from faraway countries, your reputation has travelled before you to the fatherland and, with the deeply felt satisfaction engendered by a longing to see you safely returned after so long an absence, your friends and colleagues will have welcomed you. I wish I could have been one of their number so that I could personally profit from your experience and knowledge in the realm of art but, as this was not to be, I will await with the greatest of pleasure what you have to tell me, in writing, of the arts and the sciences.* This exchange of letters was the start of an acquaintance between the Prince and Brøndsted, but it was only when the Prince came to Italy that it developed further.

The royal couple stayed only a short time in Rome.[6] Already on January 7th, 1820, they continued their journey to Naples, arriving on January 9th when the Prince had the excitement of seeing Vesuvius for the first time. The royal party took up residence in the Palazzo Scaligo in the Via Santa Lucia near the Palazzo Reale, the residence of King Ferdinand

of the Two Sicilies, who received them a couple of days later.[7] From the very first the Prince pursued his historical and archaeological interests. He attended numerous meetings in different scientific societies, becoming a member of three: Società Sebezia di Scienze ed Arti, la Società Pontaniana and Società Reale Borbonica-Accademia Reale delle Scienze, where he gave a lecture on Vesuvius on March 17th, 1820.[8] There were excursions to Pompeii and Herculaneum, to the temples of Paestum and to other archaeological sites. Many evenings were spent at concerts, performances of opera, or drama, at the Teatro San Carlo (fig. 2), and there were invitations to dinners, carnivals, shooting parties and many other social events. The two journals that the Prince kept on his long tour – a day-by-day diary written in Danish and a special travel journal mainly written in French – make it possible for us to share his experiences.[9] Already on January 15th the Prince visited the Archaeological Museum in Naples, making very careful notes about the individual statues, and covering seven pages in the journal.[10] Before the month was out a momentous event took place – the Prince paid his first visit on January 19th to Giuseppe Capece Latro, ... *einer der schönsten Greisenköpfe, die je ein antiker Marmor verewigt hätte* ... as he was described by the Danish writer Frederike Brun (fig.3).[11]

Capece Latro had been Archbishop of Taranto from 1778 to 1818 and enjoyed a large and international circle of friends, including several Danes, among them Bishop Friedrich Münter and his sister, Frederike Brun, who had spent a year in Naples 1809-1810. In his diary the Prince wrote: *Paid a visit to the Archbishop of Taranto, Fru Brun's old friend, a gentle, kindly old man ...* But it is doubtful whether the Archbishop really was so kind and gentle. He was a controversial figure in the ecclesiastical world to which he belonged, and had, for example, written in protest against celibacy. Moreover he had been involved in the disturbances and complicated political situation during the revolution of 1799, when he had been imprisoned and threatened with capital punishment. His popularity had, however, led the King to reprieve him for fear of public reaction.

The Prince's visit to the Archbishop on January 19th was the first of many and the start of a lifelong friendship between the two men.[12] The Prince gave a detailed description of this visit in his travel journal describing everything from the Archbishop's paintings to the unusual – and numerous – Angora cats, and not least their pungent smell that filled the

Fig. 3.
Bust of Giuseppe
Capece Latro made in
1810 by the German
sculptor Daniel Rauch
for Frederike Brun.
Now in the National
Museum of Denmark.

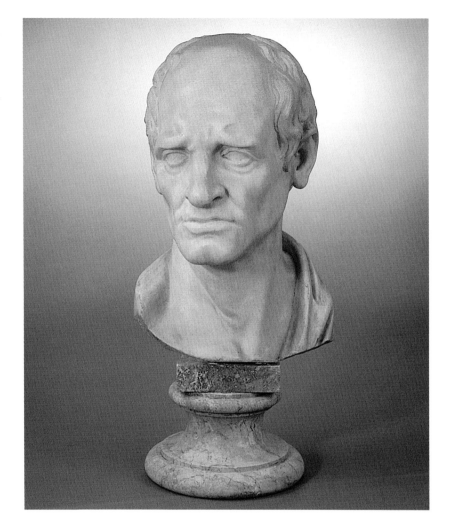

house.[13] On January 23rd the Prince paid a further visit to the cleric, and this time the entertainment included a concert and an excursion. The party went to see one of the marvels of nature and of Antiquity – the Posillippo grotto – an excursion that the Prince did not entirely enjoy, as can be read in the diary: *... but it was an unpleasant trip through an underground passage, dark and damp* (fig. 4).

In fact the grotto was a tunnel excavated in the first century AD to

connect Naples with Pozzuoli; as it was 700 m long and only 4-6 m high, the Prince's description seems fairly accurate.[14] It was on his third visit to Capece Latro, then staying at his country house at Portici south of Naples, that the Prince first saw the Archbishop's collection of antiquities and noted the vases in particular: *There are some 30 vases, some very beautiful showing Greek paintings – or Etruscan as they are called – some with inscriptions.*[15]

On one of his visits to the Archaeological Museum, the Prince was likewise much taken by the collection of vases. Moreover he was impressed by the curator of the collection, Andrea de Iorio, who had, in the Prince's opinion, presented it in a very instructive manner. The Prince noted also a model of a Greek tomb, the body outstretched with a small scent bottle on its breast, near the head some bowls, one containing coins for Charon, another with a token for Cerberus. Probably this was a model of one of the tombs in the vicinity of Paestum.[16] Such models of tombs or temple ruins could be made of wood, sugar, or of cork, and they were popular souvenirs for travellers to Italy. King Gustav III of Sweden acquired five of them on his grand tour in 1784.[17]

After this visit, and inspired by the model, the Prince's diary gives a detailed description of what can be found in the graves and what such objects can reveal about the occupation of the deceased. Here he demonstrates a genuine interest in the people of Antiquity, not just in the objects they left behind. He also comments on the restoration of the vases: *expert knowledge of their restoration is available when a broken vase is found. Moreover they are also faked to perfection to fool foreigners. However, there is a safe test for such fakes because the painting on the modern ones cannot tolerate acids and often not even water, whereas the antique paintings are indestructible.*

The Prince was also shown the collection of obscenities *dans une chambre à part* – an altar to Priapus, a Priapus herm, reliefs showing cult scenes for Bacchus, phallos amulets and – quite the worst – a statue group of a faun and a goat (fig. 5). If it had been up to the Prince, he would have had this hidden safely away.[18] When the sexually-inhibited Hans Andersen later visited the collection, his description was as follows: *To visit the Camera obscoena we had to go to the director of the museum who himself was in charge of the keys to this one room, in which one can see the most telling signs of the debauchery of the Greeks. Several lecherous pictures on limestone, different situations and ways of exercising their lusts. A lovely marble statue of a lecherous faun teaching a young person to play on a reed flute …*[19]

Fig. 4.
*The Posillipo grotto.
Painting by Michelan-
gelo Pacetti. Copied
from Giovanni Battista
Bassi (1784-1852).
Thorvaldsen's Museum.*

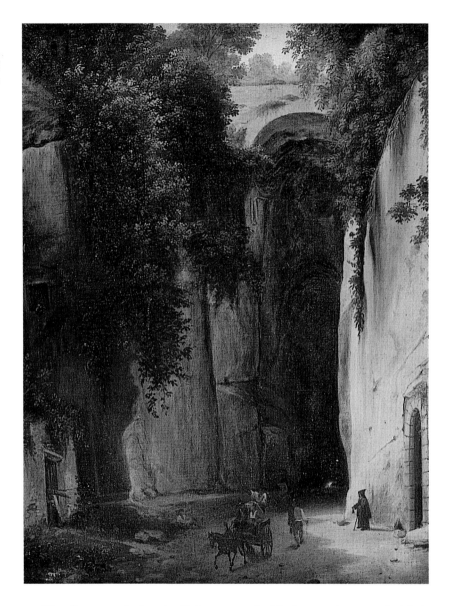

The first month that the Prince spent in Naples was in general rich in archaeological pursuits. Already on January 23rd he heard a lecture at the Società Reale Borbonica about the work being done on the papyri

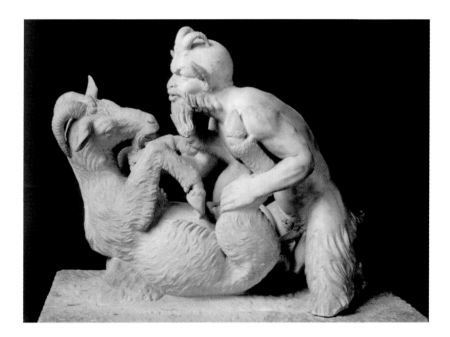

Fig. 5.
Faun and goat. Sculpture from the peristyle of Piso's villa in Herculaneum. Marble. Second century BC. Archaeological Museum, Naples.

found in Herculaneum. The following day he visited Herculaneum itself (fig. 6), studying the murals, their colours and motifs, and afterwards describing them – together with the ruins and the history of the excavations – in four closely-written pages in the travel journal. On a visit a few days later, the Prince saw how English and Italian archaeologists were unrolling the papyrus scrolls found in 1752.[20] He gives no details of the methods employed, but Ludvig Bödtcher, a Danish poet, who visited Herculaneum a few years later, gave a lively account: *I was much interested in seeing the Papyrus Cabinet and the machine designed to unroll the papyri which, when I was there, was hard at work. It takes incredible patience and care, and the ancient scrolls looked exactly like American chewing tobacco.*[21]

P. O. Brøndsted arrived in Naples from Rome at the end of January. Together with the Prince, he made several visits to the Archaeological Museum where they selected the statues that were to be copied for the Royal Academy of Fine Arts in Copenhagen.[22] The Prince had been President of the Academy since 1808 and took care to carry out the duties of this position throughout his tour. However, Brøndsted had not come to Naples to be a companion to the Prince, for he intended to

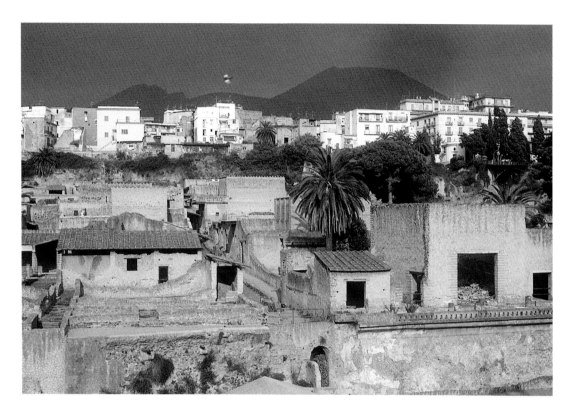

Fig. 6.
View of Herculaneum with the modern town and Vesuvius in the background. Herculaneum had been covered by mud which had protected the buildings up to a height of two storeys. The first excavations were made by tunneling.

travel to Greece again. Christian Frederik would no doubt rather have kept him at his side for archaeological excursions and as an intellectual companion, but Brøndsted was given permission to leave for Athens. Thereafter the Prince continued to pursue his archaeological interests, visiting Pozzuoli, Pompeii and Paestum in February. Careful notes were made on everything he saw: the landscape around Pozzuoli and Lake Averno which, with reference to Vergil, he described as the entrance to Pluto's kingdom. Six pages of the travel journal are devoted to describing the ruins of the Pozzuoli thermal baths and the Serapis temple, whose floor was covered in water: the Prince wondered whether it was the land or the sea that was subject to change.[23] He admired the beauty and solidity of the temples at Paestum, and the young Danish architect Jørgen Hansen Koch, a member of his party, took measurements of the columns.[24] One of the temples, the so-called Poseidon temple, was a

Fig. 7.
Cork model of the Poseidon temple at Paestum. Beginning of the nineteenth century. Gift from the Ny Carlsberg Foundation 1994. (Inv. no 15631).

favourite subject for the earlier-mentioned model makers – it was extremely well preserved and considered to be the very quintessence of a Greek temple – an opinion still valid today. The Prince could certainly have acquired a model of it as a souvenir of his trip to Paestum but, as far as we know, this was not the case.[25] In 1994 the Department of Classical and Near Eastern Antiquities made good this omission by acquiring a model of the temple, probably made around the time of the Prince's grand tour (fig. 7).

A winter in Naples had far more to offer than museums and ruins. For the Carnival, Christian Frederik and Caroline Amalie wore Spanish costume, and the Prince was a guest at several of King Ferdinand's shooting parties. One such, at Carditello east of Naples, provided the Prince with his first experience of hunting wild boar. To the King's satisfaction the total game bag that day was 29 wild boar, 8 roe deer, 4 foxes, 10 hares and 97 snipe. In other ways too this was a notable excursion, for the Prince's carriage, shared with Prince Jablonowsky, Austrian ambassador to Naples, broke down on both the outward and the homeward journies – episodes described with much mirth in the diary.[26]

At the end of March the royal couple had, much against their will, to leave Naples. The diary's comments on their time in Naples are ecstatic: both the wonderful climate and the people with whom the Prince had become acquainted were given the highest praise.[27] The length of time that King Frederik VI of Denmark had originally allotted for the couple's journey was fast running out, and although the Prince had requested an

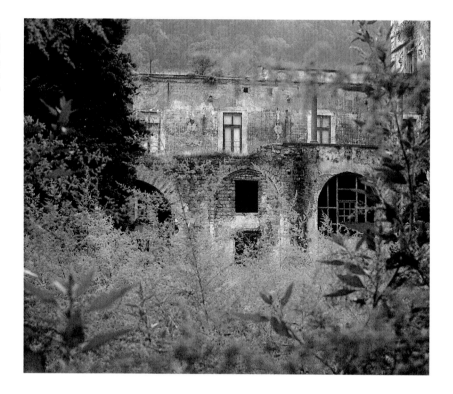

Fig. 8.
The Villa Quisisana
today. It was destroyed
by an earthquake in
1980 and stands today
as a ruin surrounded by
its luxuriant park.

extension this had not yet been granted.[28] The royal party left Naples on March 21st for Rome, where they stayed at the Palazzo Negroni. Shortly after their arrival the Prince was taken ill, and before he was well enough to start the homeward journey, they received the King's approval of an extension to their grand tour up until the summer of 1821. A month later, on May 11th, the couple set off to return to Naples,[29] taking up residence in the Palazzo Calabrito in the middle of the town on May 13th.[30] Some time later, King Ferdinand offered them the use of the Villa Quisisana, a summer palace at Castellamare, ancient Stabia, on the southern coast of the Bay of Naples. The recently refurbished Villa[31] was set in a luxurious park surrounded by beautiful countryside on the mountain slope above Castellamare. At Quisisana the Prince spent an eventful period of his life (fig. 8). Besides archaeological excursions and the social round, the couple's residence at Quisisana coincided with the political disturbances that began in July. The Prince followed develop-

ments very closely, noting down his observations daily. These matters must have been of much interest to him, for he filled a whole journal describing the situation and giving his opinion of events.

The Prince also had the opportunity of renewing old acquaintances. Capece Latro was by now very keen to sell his collection of vases and, since the Prince was willing to purchase it, negotiations gradually got under way.[32] Capece Latro suggested an arrangement involving the payment of 200 Neapolitan ducats a month to him for the rest of his life. On July 17th it appears that the Prince had definitely decided to purchase the collection – but not to pay this price. Very briefly, the diary reports: *later to the Archbishop, next time we must get down to putting a price on the vases.*[33] Eventually Capece Latro and the Prince agreed to ask Andrea de Iorio from the Archaeological Museum to value the collection. Iorio had already given proof of his knowledge on the Prince's earlier visits to the Archaeological Museum, when he had interpreted the depictions, often wedding scenes, on the large vases.[35] He was therefore a professional whom the Prince thought highly of, but nevertheless a second opinion was desirable. On August 23rd the Prince requested the Archbishop to allow Brøndsted, who had by now arrived in Naples, to look at the collection. Brøndsted immediately carried out his instructions, making a very thorough examination of the vases and sending the Prince a detailed description of them, sorted into different categories, already on August 28th.[36] Fifteen or sixteen are classed as *superior*, one of which is *ranked as first class – perhaps two others, which are also quite splendid* could be classed here, but this would take *more detailed study of the decorative scenes.* Of the remainder, there are *only very few that could induce me to spend appreciable time interpreting their scenes.* The factor that frightened Brøndsted was the ... *heavy-handed restoration that most have undergone.*

Hence Brøndsted only dealt in detail with a few of the vases, those which he felt to be of particular interest or those posing special problems. In fact, this selection was almost identical with thirteen pieces that Capece Latro himself had described and interpreted in detail (fig. 9).[37] Brøndsted thought rather little of Capece Latro's attempts at interpretation, calling his efforts: *a quaint example of all kinds of pretty and Christian sentiments that an otherwise agreeable prelate, with superficial knowledge of the nature of Hellenic Antiquity, can lend to the sometimes quite shameless artists of these brilliant people – sentiments that the old rogues could never have dreamt of.*

Interpetrazione di alcuni Vasi Etruschi esistenti nella collezione di Sua Eccellenza Monsignor Giuseppe Capece-Latro Patrizio Napoletano antico Arcivescovo di Taranto

N.° 1.

N.° 1.

[Manuscript text in French and Italian, in cursive handwriting.]

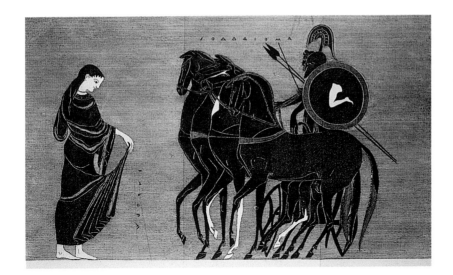

Fig. 10.
Black-figure amphora
from Capece Latro's
collection. Illustration
from Abbot Scotti's
treatise.
(Chr. VIII 3)

The vase that attracted Brøndsted's special attention was a black-figure Attic amphora from the end of the sixth century BC. This shows King Amphiaraus bidding farewell to his wife Eriphyle, before leaving for Thebes. Brøndsted considered this vase to be the best in the collection, since it had *the considerable advantage of being one of the least restored and yet one of the best restored.* He estimated its value to be 3000 ducats – a considerable share of the total valuation of the collection and clearly showing that Brøndsted preferred Attic vases. The same vase had already attracted the attention of the Archbishop, who had requested the learned Abbot Angiolantonio Scotti to make a study of it.[38] Posterity has proved Brøndsted both right and wrong in his evaluation (figs. 10-11). On detailed examination the vase appeared not to be the *least* restored but quite definitely the *best* restored specimen; so well had the work been carried out that neither Brøndsted nor the Prince noticed anything amiss, and yet both were aware that many of the vases had been heavily restored.[39]

Two other vases were singled out by Brøndsted as *first-rate*, an Attic red-figure stamnos and a large red-figure amphora from Apulia, but these two also were later proved to belong in the *best restored* category. The overpainting of the Attic stamnos was removed in 1915, revealing a very worn surface on which only the outlines of the figures could be discerned (fig. 12). Brøndsted noted that the motif seemed to be taken from

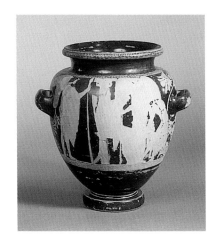

Fig. 11.
The vase fig. 10 after
its restoration in 1977.

Fig. 12.
Red-figured stamnos
showing King Phineus
surrounded by the sons
of Boreas, the North
Wind. (Chr. VIII 8)

the story of Sappho, an interpretation he shared with Capece Latro, but here both were mistaken. In fact, the scene shown is from the tale of the Argonauts depicting King Phineus surrounded by the Boreadae, sons of Boreas, the North Wind, an unusual motif.[40]

Brøndsted refrained from studying the motifs on the other large vases in the collection − seven large South Italian showpieces − on the ground that they confirmed his *earlier concluded and now further confirmed opinion of the heavy-handed restoration that most pieces have suffered*. Also in these cases he was entirely correct.

There were some well-preserved specimens in the collection though; for example, a krater from the fourth century BC showing a symposium, and a group of black- and red-figure vases found at Nola, including a kylix from the fifth century BC, decorated with school scenes.[41] Brøndsted put the value of the total collection at 20 000 ducats, but he would have nothing to do with the conversion of this sum into an annuity to be paid monthly. Of course, he warmly recommended the purchase of the collection, adding that the vases would be an asset to Denmark. The Prince had earlier made it a condition for the purchase of the collection that ten marble portrait busts should be included, and Brøndsted suggested that a further five should be added to this arrangement. Although some of the fifteen sculptures later proved to be of more recent date, a few are now among the finest objects displayed in the Collection of Classical and Near Eastern Antiquities. In particular two portrait busts of the

young Germanicus and of Drusus Minor, princes of the Julio-Claudian dynasty (fig. 13),[42] and an altar decorated with figures on all four sides and probably erected in Taranto by Agrippa, Augustus's general and son-in-law, some time after the victory at Actium in AD 31.[43]

The vases constituted the important part of the Archbishop's collection and they were also the Prince's main interest. The purchase covered a total of 180 small and large decorated vases, representing the various styles characteristic of different areas in Southern Italy: Campania, Lucania and Apulia; a large group of the so-called Gnathia pottery with the characteristic white decoration on a black ground, fluted or stamped decoration, and no less than 63 entirely black-glazed vases, figs. 14-16.[44] As mentioned earlier, there were just a few Greek vases, and some of these much restored, only the small Nola group being well preserved.[45] However, the Archbishop had collected objects other than vases: terracotta figures, loom-weights, lamps and glass, as well as some 100 bronze figures, tools, fittings and jewellery. These were also included in the sale although Brøndsted considered them to be of little value.[46]

Andrea de Iorio had put the value of the collection at roughly 17 000 ducats – almost the same as reckoned by Brøndsted, but the Archbishop still desired to have an annuity of 200 ducats paid monthly. The Prince was disinclined to agree with this arrangement – for who knew how long the Archbishop might survive? On September 9th he wrote in his diary: *Visited the Archbishop. This day I completed transactions with him for the purchase of his vases and marbles against a monthly payment of 150 ducats so long as he lives.* On September 20th a contract was signed showing which items were included in the sale.[47] Nobody was to know that the arrangement was to prove an expensive one in spite of the Prince's care. At the time of the sale Capece Latro was already 77 years old, but *he was parsimonious enough to live on until he was 92.*[48] The collection therefore came to cost not 20 000 but 28 000 Neapolitan golden ducats.

The collecting of antiquities was a very popular pursuit in the Naples region, and even the director of the Naples Museum, Giuseppe Crescenzo, had his own private collection. This the Prince viewed on September 28th, and his diary shows that, on November 29th, he purchased six vases from Crescenzo at a cost of *1500 ducats, 300 to be paid immediately and 100 every month for a year: a good transaction for the vases are splendid.* Although one of these vases in particular had undergone heavy-handed restoration,

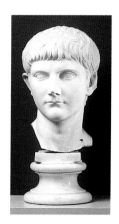

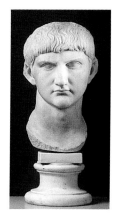

Fig. 13.
Two princes of the Julio-Claudian dynasty. 1st century AD. Found in the theatre at Taranto.
(Chr. VIII 305 and 303).

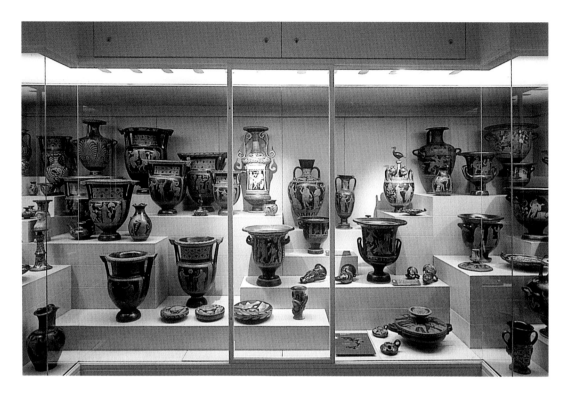

Fig. 14.
The collection of South Italian vases as displayed in the National Museum today.

there were indeed several *splendid* specimens. The vase that had suffered from its restoration was an imposing krater with large volute handles, and a representation of the Ethiopian King Memnon coming to the help of the Trojans during the siege of Troy.[49] Later, both the neck and the large handles were found to be modern additions but the pictorial representation had only been slightly improved (fig. 17). The Prince later purchased other vases from Crescenzo, giving a total of 17.[50] Among the *splendid* ones are two large wedding vases showing a series of scenes of wedding preparations of the kind that Andrea de Iorio had explained in such lively detail to the Prince.[51] One large krater attracted special attention and was published already in 1826 by Børge Thorlacius,[52] a professor of philology. This shows a scene known from Aeschylus' tragedy *The Eumenides*: Orestes is seeking shelter in the sanctuary of Apollo at Delphi from the fury of the goddesses of revenge, the Erinyes, after he had avenged the murder of his father Agamemnon by killing Clytemnestra, his own mother.[53]

Fig. 18.
Finds from the Cumae
excavations.

collection and the Crescenzo vases that were to become the nucleus of
the later Vase Cabinet.

The royal couple spent their last day in Naples on November 29th,
1820. They had much appreciated the opportunity to stay at King Ferdi-
nand's summer palace and, as a farewell gift, the Prince commissioned Jo-
han Christian Dahl, the Norwegian landscape painter, to make a painting
of the Villa Quisisana for the King (fig. 19).[58] The Prince set great store
by Dahl and during the summer had arranged for him to travel to Naples
from his home in Dresden.[59] Dahl participated in some of the archaeo-
logical excursions, in Cumae making a sketch of one of the Roman
graves opened during the Prince's visit.[60] The royal couple's occupancy of
the Villa Quisisana was long remembered in the area. When the Danish
poet Ludvig Bødtcher visited the Villa in 1825 he described it as follows:
*Everything in the Villa Quisisana was doubly remarkable to us because Prince
Christian and his wife had spent the hottest months here when staying in Naples.
We found it infinitely pleasing that the word "Danish" was known and liked by
all here, and nobody spoke of the Danish princess without adding "la Bella".*[61]

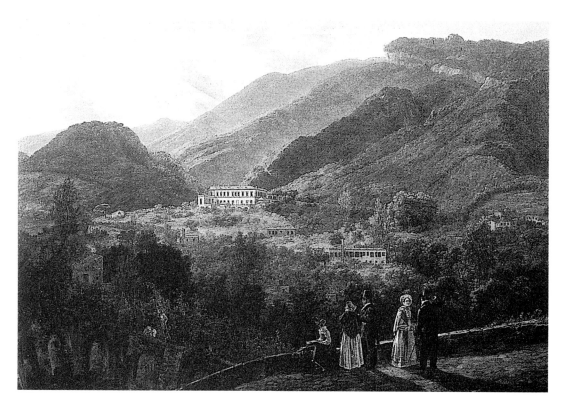

Fig. 19.
Landscape showing the
Villa Quisisana and
the royal party in the
foreground. J.C.Dahl,
1820. Museo Capodi-
monte, Naples.

The royal couple left for Rome and never returned to Naples. Remaining in Rome until April 1821, the Prince still pursued his archaeological interests but does not seem to have acquired any objects for his collection[62] except a couple of architectural fragments and a Christmas present from P.O. Brøndsted.[63] Before leaving Naples it had been agreed that Capece Latro's vases were to remain there until suitable transport could be arranged to Denmark. This did not occur until 1825 when the collection was sent to Copenhagen on board the corvette St. Croix.

During the first few years after returning from Italy, the Prince seems not to have acquired anything important for the Vase Cabinet. Nevertheless the collection was already reckoned to be of a very high standard. Børge Thorlacius, while on a visit to Berlin in 1826, wrote to his friend Johan Adler: *No collection is to be found here such as that of His Royal Highness Prince Christian with respect to the varieties of shapes or the size and splen-*

Fig. 20.
Two jugs from Karthaia
on the island of Keos
(Kea). 550-400 BC,
gifts from P.O. Brønd-
sted to Prince Christian
Frederik. (Chr. VIII
342 and 343)

dour of the pieces. Thorlacius purchased different antiquities on his European tour, which lasted from 1826 to 1828, and some were later included in the Prince's collection.[64] A few years after Prince Christian returned to Denmark he came into contact with Christian Tuxen Falbe, a consular officer with archaeological interests particularly concerning Carthage.[65] Brøndsted and especially Falbe were quick to exploit the rich opportunities of acquiring antiquities during the nineteenth century. Both men purchased numerous objects during travel and residence abroad for their personal collections or for the Prince's Vase Cabinet, and both must be given a large part of the credit for the development of the royal collection into one of the most important in Northern Europe. Brøndsted had already demonstrated his preference for Greek pottery when making his study of the Archbishop's vase collection, and he had become an eminent archaeological authority through spending many years in Greece. On his return to Copenhagen in 1832 he was appointed professor at the University and head of the Coin Cabinet at Rosenborg Palace. In the following years he presented numerous antiquities to the Prince, among them two small jugs from his excavations on the island of Keos (fig. 20).[66] In 1832 he gave the Prince two Greek vases that he had acquired in London; both originated from the excavations at Vulci

in Etruria.[67] One is a so-called psykter, a wine cooler, the other an un-usually large lekythos with a representation of the birth of Athena. Both these pieces are evidence of Brøndsted's flair for Greek art, and they are still among the finest vases in the collection of the National Museum (fig. 21).[68] Naturally both were among the objects chosen to illustrate the catalogue of the Prince's collection proposed by Falbe and the archaeo-logist J. L. Ussing at the end of the 1840s (fig. 22).[69]

The Prince spent a lot of time in the Vase Cabinet in the 1820s and 1830s and was much involved in all acquisitions. After he succeeded his cousin King Frederik VI on the throne of Denmark, in 1839, there was less time for the Vase Cabinet. Work on the collection and decisions re-lating to acquisitions were increasingly left to Brøndsted and Falbe, but they maintained very close contact with the King.

The Prince kept in contact with Italy after his return to Denmark. Al-ready in 1821 there was some talk of his acquiring the collection of Bish-op Torrusio, but this did not happen. Torrusio did, however, send the Prince a gift, a small red-figured pot, a so-called pelike, from the fifth century BC.[70] The Prince corresponded regularly with Capece Latro, and three letters from 1833 indicate that the Archbishop intended to send the Prince some reproductions of Pompeian mosaics. These were painted copies in miniature of two of the newly excavated mosaic floors; the ex-tremely impressive Alexander mosaic from the Casa del Fauno that had been excavated in 1831, and a so-called Nile landscape with reproduc-tions of birds, crocodiles, hippopotami, and snakes. Both mosaic floors are now in the Archaeological Museum in Naples, while the copies given to the Prince are in the National Museum in Copenhagen (fig. 23).[71] Three small clay pots catalogued with the additional note *Capece Latro 1833*, in-dicate that these also were gifts from the Archbishop.[72] Another of the Prince's acquaintances in Naples was Rafael Gargiulo, who restored an-tiquities. He too sent gifts to the Prince including South Italian, Attic and Corinthian pottery.[73] Among these gifts was a Corinthian skyphos with animal friezes, a type not then represented in the Prince's collection.[74] Gargiulo restored vases for several Neapolitan collectors, and today both the Archaelogical Museum in Naples and the National Museum in Den-mark have vases that were restored by this craftsman. During the nine-teenth century many auctions of antiquities took place in Europe, but the Prince was not always able to authorize Brøndsted to make purchases on

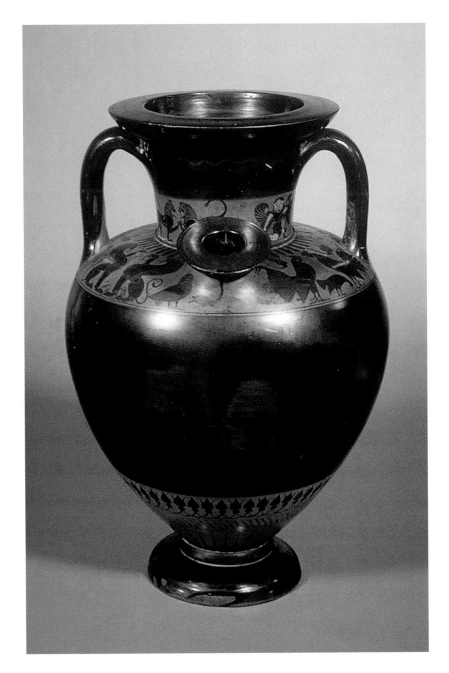

Fig. 21.
A psykter (wine cooler).
From a Greek colony
in South Italy, c. 540
BC.
(Chr.VIII 326).

his behalf. When the great collection of Eduard Durand, a French collector, was sold by auction in Paris in 1836, Brøndsted offered his services as purchasing agent to the British Museum because, he considered, their collections showed a number of gaps.[75] Thus Brøndsted had the oppor-

tunity to purchase what he called a *systematic series of splendid Greek vases*. After the auction he wrote to the Prince: ... *how often I thought of your collection, my lord! Oh, I sighed at times, if only I could have acquired these wonderful objects for my Prince.* Brøndsted himself bought some scarabs and a pair of gold earrings which he later presented to the King.[76] Although the Vase Cabinet had to do without any vases from the Durand sale, the Royal Coin and Medal Cabinet was more fortunate, for Brøndsted – carrying out the duties of his official position – purchased 121 Greek silver and bronze coins.[77] Neither could Falbe always persuade the Prince to give him authority to make purchases on his behalf. The Prince could not, for instance, make up his mind to authorize Falbe as his agent at the auction of the Magnoncourt collection in 1837; but this did not prevent Falbe from purchasing seven important vases on his own initiative. All were later included in the Vase Cabinet.[78]

Brøndsted's last purchase for the Vase Cabinet was made at an auction in London in 1840. This was a magnificent red-figure wine jar, a so-called stamnos, with a representation of a young man, Eucharides, with two women (fig. 24). Brøndsted interpreted this scene as a young man being initiated into the mysteries, and perhaps in a way he is right, for Eucharides is paying a visit to two hetairai.[79] Among his many activities, Brøndsted started to give lectures on Greek vases at the University in

*Fig. 23.
Copy painted on marble of the Alexander mosaic from the Casa del Fauno, Pompeii.*

Fig. 24.
A stamnos. Attributed
to the Eucharides
painter. C. 460 BC.
(Chr. VIII 484).

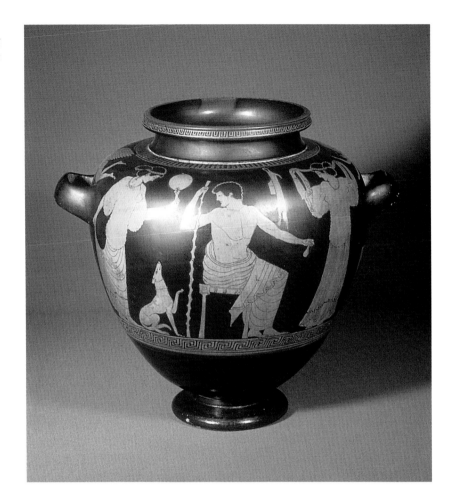

1836. He asked Falbe to lend him *some vase or other* to show to his students. The Prince was consulted and replied: *Of course, we should allow him to borrow a single specimen, but if he wishes to give his students a general impression of the vases, their shapes, significance, and the pictures on them, he should take them to the Cabinet.* This response makes us sure that the Prince would be delighted by what goes on any day in the Museum: groups of school children and numerous university students visiting the vases to get that general impression he felt to be so important.

In 1847 Falbe took the initiative for the purchase by the King of the

Fig. 25.
A wood-carver working on a herm. Scene depicted on the interior of a kylix. attributed to the vase painter Epiktetos. 520-500 BC. One of the "Hansen vases". (Chr. VIII 967)

Hansen vases. These were part of a collection of more than 200 antiquities acquired by Christian Hansen, a Danish architect, who lived and worked for many years in Athens. Sad to say, the collection as a whole only reached Copenhagen in 1848 after the King's death. Not since the acquisition of the Capece Latro collection had so many new items been added to the royal collection. It had now become a truly representative collection of Greek pottery and a richly-facetted and invaluable source for understanding the cultural history of classical Antiquity.

Appendix

Inventories and catalogues of Christian VIII's Vase Cabinet. Held in the archives of the Collection of Classical and Near Eastern Antiquities

Interpetrazione(sic) di alcuni Vasi Etruschi esistenti nella collezione di Sua Eccellenza Monsignor Giuseppe Capece Latro, Patrizio Napoletano antico. Arcivescovo di Taranto.

A double-columned description in French and Italian of thirteen vases, twelve from South Italy and one no. XIII from Egypt. The handwriting does not seem to be that of Capece Latro but is probably that of a secretary. The crowned monogram of Prince Christian Frederik decorates the first page. Folio, unpaginated.

Notamento ristretto de' No XIII Vasi de' più interessanti della raccolta di S. E. Monsignor Arcivescovo di Taranto.

First thirteen vases are listed I-XIII, then follows a list numbered 1-317 headed:
Siegue il notamento del resto de' Vasi.
A short description is given of each object, measurements in palmi, provenance, valuation in piastres, each entry has a space for *osservazioni.*

The total value is set at 10719.5 piastres.

The inventory is signed on the last page by Andrea de Iorio and Raffaele Gargiulio. The crowned monogram of Prince Christian Frederik is on the first page. Folio. Unpaginated.

This inventory listing vases and other objects in Capece Latro's collection was drawn up in connection with its purchase by Prince Christian

Frederik. It was made by Canonicus Iorio and the illustrious Sig. Gargiulio. A letter of September 1st 1820 from Capece Latro to Christian Frederik (now in the Royal Archive in the National Archives) mentions this inventory.

Catalogo della Raccolta de' Vasi Italico-Greci di S.A.R.il Principe Cristiano Frederigo, classificata per diversita delle forme dalla Medesima Sua Altezza Reale.

Undated, but probably prepared by C. T. Falbe in collaboration with Prince Christian Frederik. It comprises both the collection of Capece Latro, numbered I-XIII and 1-418, and objects with different provenance 1-517. The catalogue is in Italian and has an introduction explaining the two numbering systems:
Not. I numeri col appostata nota -✝- sono dalla collezione di Monsig. Arcivescovo di Taranto. Questi numeri sono segnati con ciffri Romane dal No I à XIII; e con ciffri arabi dal No 1 fin al numero 418.

Il resto delle antichità di questo Gabinetto, sono segnati dal numero 1. fin a quanto sara? in ciffri arabi, ed hanno di più un nome o una lettera iniziale, indicativo della persona o del luogo donde provengono.

Folio, unpaginated 90 pages. The crowned monogram of Prince Christian Frederik is on the title page.

Some handwritten sheets supplement the ca-

50 of bronze and 21 of marble were found in the excavations. The erotic group of Pan and a goat is from the second century BC and comes from the large peristyle, which had Dionysian decorations. See Naples 1996, 291, inv. no. 27790. See also Il Gabinetto Segreto 1971.

19. H.C. Andersens Dagbøger 27 February 1834. During his first visit to Italy in 1833-34, Andersen stayed in Naples from February 16th to March 20th, 1834. The Pan and Daphnis group is a Roman copy of a Greek original from the second century BC. See Naples 1996, p. 329, inv. no. 63929 belonging to the Farnese collection.

20. No fewer than 1758 papyrus scrolls were found in the library of Piso's villa. Many had Greek texts dealing with Epicurean philosophy. John Hayter, a British archaeologist, worked on their unrolling, which took all of thirty years to complete.

21. Hartmann, 1993, 80.

22. During a visit on February 3rd, 1820 Christian Frederik continued his notes on the sculpture nos. 284-426. Dagbøger 3 February 1820, p. 211.

23. Andrea de Iorio's *Guida Pozzuoli e Contorni* appeared in 1822, too late for the Prince to get an answer to his query.

24. The day after his arrival in Naples Christian Frederik had visited the church of S.

Francesco di Paula, which was undergoing restoration. While there he proposed that the young Danish architect Jørgen Hansen Koch should participate in the restoration work.

25 The earliest known model of the Poseidon temple was made by Agostino Rosa in 1777, and was very heavily influenced by the drawings made by Giambattista Piranesi in the same year and published in 1778. Today the model is in the St. Germain-en-Laye museum (inv. no. 49.795).

26. A very lively description of this remarkable hunting expedition is given in Dagbøger og Optegnelser 22 January 1820.

27. The Prince wrote this in the French-language travel journal, Dagbøger og Optegnelser, 21 March 1820.

28. Already on February 1st Christian Frederik had written to Frederik VI for permission to extend his time abroad.

29. The objects of interest viewed on the journey south are described in Dagbøger og Optegnelser 11-13 May.

30. The Palazzo Calabrito is in the same quarter as the Palazzo Sessa which Sir William Hamilton moved into in 1764, and where he established his collection of antiquities.

31. In March, already before the royal couple left the area, the King had offered them use of

the Villa Quisisana; so he was repeating his offer. Quisisana was later to become a hospital for Garibaldi's volunteers, and still later it was turned into an exclusive hotel – the Albergo Reale e Quisisana – much used by British travellers visiting the health-giving baths in the area. Today the Villa lies in ruins, destroyed by a violent earthquake on November 23rd, 1980.

32. The Prince had not earlier purchased any antiquities and it seems as if the idea of a complete collection appealed to him. See also Slej 1995.

33. Dagbøger og Optegnelser 17 July 1820.

34. Dagbøger og Optegnelser 24 July 1820.

35. Optegnelser 26 February 1820, Royal Archive, National Archives. The Prince noted down Iorio's descriptions but, in the middle of a lengthy description of a large vase, his ink came to an end so he continued in very faint pencil.

36. Breitenstein 1951, 64 reprints the letter. Now in the Royal Archive.

37. Today this description, in Italian and French, is in the archives of the Department of Classical and Near Eastern Antiquities in the National Museum of Denmark.

38. Scotti 1811.

39. Trolle 1980.

40. Chr. VIII 8, CVA pl.150, 2a-c; ARV[2] 502,7. LIMC III, p. 128, no. 16, pl.103 and LIMC

VII,1,389.

41. Red-figure krater, Chr.VIII
83, CVA pl.355, 2a-b; Para-
lipomena, 491,31, the Black-
Thyrsus Painter. Kylix show-
ing school scene Chr.VIII
273, CVA pl.161,2a-c; ARV²,
395,7, The Painter of the Yale
Cup.

42. Chr.VIII 305 and 303.

43. Chr.VIII 314. Riis, 1952.

44. Breitenstein 1951, 74, note
44-53.

45. Chr.VIII 113, 117, 29, 55 =
CVA pl. 112,11-13 and pl.
122,4.

46. Breitenstein 1951, 74.

47. In the Royal Archive, Na-
tional Archives.

48. Ewald 1905, 112.

49. Chr.VIII 286; Breitenstein
1951, 87.

50. It is difficult to distinguish
the first six vases among the
seventeen. For the vases from
Crescenzo see Breitenstein
1951, 86-88.

51. Pelike Chr.VIII 316. Wedding
vase Chr.VIII 377.

52. Chr.VIII 332.

53. Breitenstein, 1951, 88.

54. In his French-language travel
diary the Prince gives a de-
tailed description of Torru-
sio's vase collection and men-
tions the Bishop's *idée sin-
gulière* that cataloguing the
collection would decrease its
value. Dagbøger og Opteg-
nelser 19 February 1820.

55. Dagbøger, II, 1.

56. For further details of the trip
to Nola see Breitenstein
1951, 78.

57. Notes in the Royal Archive,

National Archives. The six
pages are written, unfortu-
nately, in very light ink and
small handwriting making
them virtually illegible.

58. Dahl 1987 no. 32. Christian
Frederik's liberal opinions did
not endear him to King Fer-
dinand at this time so their
previously warm relationship
had become somewhat
strained, and a year passed be-
fore this painting could be
handed over to the King.

59. Dahl, however, was not so
enthusiastic about the time
he spent at Quisisana where,
in his opinion, too much
time was wasted on social ac-
tivities. Dahl 1987, 35.

60. This drawing has now been
lost. For a reproduction see
Breitenstein 1951, 83, fig. 13.

61. Hartmann 1993, 81.

62. The archaeological expedi-
tions of the royal couple are
described by Slej 1995, 183-
191.

63. Breitenstein 1951, 90.

64. Breitenstein 1951, 98.

65. See Lund's contribution to
this volume, p. 119.

66. Chr.VIII 343 and 342; Breit-
enstein 1951, 199; Lund and
Rasmussen 1994, 195.

67. Breitenstein 1951, 100.

68. Chr.VIII 326, CVA pl.97, 2a-
b; Koch-Harnack 1989, 61-
62, fig. 42. Chr.VIII 375,
CVA pl.132,6; Lund and
Rasmussen 82 and 97.

69. See Lund's contribution to
this volume, p. 119.

70. Breitenstein 1951,82 and
fig. 11.

71. The mosaic copies are paint-
ed on marble slabs measuring
34.5 x 17.5 cm and have the
following inscription on the
reverse: *A.S.A.R. Christiano
Frederigo Principe Ereditario di
Danimarca dal Vecchio Arcivesco-
vo di Taranto. Mosaico trovato a
Pompeji.*

72. Chr.VIII 415, 480 and 663.

73. South Italian vessels, Chr.VIII
319, 400 and 341; Attic ves-
sels Chr.VIII 381, CVA
pl.112,7; ABV 540,23 and
Chr.VIII 299, CVA pl.153,2;
ARV², 1140,22.

74. Chr.VIII 498, CVA pl.91,3;
Amyx 1988,290. See Breiten-
stein 1951, 104 for other de-
tails of the gift. Other vases
from Gargulio were acquired
in Naples at the end of the
19th cent. See La Magna
Grecia 1996, 46.

75. British Museum Archives,
Original Papers XIV,17 avr.
1836. L'Anticomanie, 270.

76. Durand 1836, no. 1984, 2175,
2182-3, 2190, 2193; Ras-
mussen 2000, 94, fig. 8
(Chr.VIII 768).

77. Steen Jensen 1980, 87-94.
And letter to A.W. Hauch,
Head of the Cabinet, dated
London June 4th, 1836.

78. Breitenstein 1951, 130.

79. Chr.VIII 484, CVA pl.134,
1a-c; Meyer, 1988,106, Abb.
11-12; Lund and Rasmussen,
1994,78.

Christian VIII as numismatist: his collections of coins and medals

Jørgen Steen Jensen

One could almost say that an interest in coins and medals is part and parcel of the royal life, and an obligatory part of the king's official duties. As far back as Hellenistic time coins have been decorated with the monarch's portrait, and medals have been struck in Europe since the middle of the fifteenth century. A medal is actually a "display" coin, generally commemorating a person or event, but not legal tender. In Denmark a few medals were first struck during the reigns of Frederik I (1523-1533) and Christian III (1534-1559). Medals were often struck by royal command, that is by the king and intended for his own personal glorification. Hence the striking of medals and their presentation to selected recipients was a kind of high-level propaganda. If you had been given a gold medal, and perhaps wore it on a chain round your neck, it marked a special relationship between yourself and the donor of the medal. Even without this visible evidence though, a collection of medals was a status symbol of rather special significance. We know that Danish kings and aristocrats collected the best specimens of their own times, but it can be difficult, for example in the late Middle Ages and the sixteenth century, to tell who actually owned which medal. The best specimens held by the Royal Collection of Coins and Medals in the National Museum today were clearly items in collections ever since they were struck,[1] and this can have taken place half a millennium ago. Since the time of Frederik III virtually all the Danish kings have either acquired coins and medals specially for the collection that is now held by the National Museum, or after the monarch's death the collection has received the medals he acquired during his lifetime. This also applies to the last three Danish monarchs of the Glücksborg dynasty.

One of these royal collectors, King Christian VIII,[2] surpasses all the

others in his involvement with the collection. He was the only Danish monarch to be personally responsible for the acquisition of a large collection of ancient Greek coins and, apparently, the only one to build up a collection of revolution medals. The last factor, which sheds some light on the King's personality, is dealt with later in this chapter. It is worth mentioning that the King also possessed a large collection of Roman coins, in part inherited from his father, Prince Frederik. Prince Christian Frederik's tutor, Ove Høegh-Guldberg, later a very influential cabinet secretary and himself a knowledgeable numismatist, undoubtedly inspired him to start his own collection, and Høegh-Guldberg pulled the strings when the Royal Collection of Coins and Medals was set up in 1780-81.[3] In fact, Christian VIII's Roman coins were probably the least remarkable group of his medals and coins, for they were relatively easy to acquire and had already been collected for centuries, being included, for example, in Frederik III's collection. The Roman items in the coin collection of the National Museum have thus, in the main, their origin in older collections from the seventeenth, eighteenth and nineteenth centuries. Moreover the still useful, but of course out-dated, printed catalogue of the Roman collection was issued before Prince Christian Frederik became king.[4]

One remarkable and indeed unique factor when studying the coins of Christian VIII is the overwhelmingly detailed information left to us by the unusually communicative monarch. His diaries alone record all the details of how his numismatic enthusiasm grew from a polite interest to impassioned collecting.[5] The journey that Christian VIII made to Italy in 1820-21 was the decisive turning-point for his great and abiding interest in Greek coins.

The later diaries give fewer details, but this does not mean the King's interest slackened but rather that, to an increasing extent, he left work on the collection to Christian Tuxen Falbe. Falbe took over where his master had left off by initiating new, handwritten catalogues, prepared with the greatest care.[6] The language was French, just as it was in the first catalogues prepared by Prince Christian Frederik and Peter Oluf Brøndsted. The catalogues contained not only summarized descriptions of the coins or medals but also supplementary information considered of interest, hereunder not least the highly important *provenances*. It is worth mentioning here that Christian Ramus, head of the collection from 1799 un-

til his death in 1832, had no interest in the provenance of the coins, and as a result this is often unknown to us today. Christian Jürgensen Thomsen, on the other hand, was very careful to note the provenance but only for the national collection which he served with such diligence. There are virtually no provenances given for the coins in his own very considerable and highly-famed collection. Falbe obviously recognized the importance of provenance, and the same applies to Brøndsted, who followed Ramus as head of the Coin Cabinet (1832-1842) and started several of the series of record ledgers (gift and exchange records) that make it relatively easy to identify the provenance of many of the items acquired for the public collection from 1835 onwards.[7]

To return to the Prince's journey to Italy and its importance for his interest in Greek coins:[8] on March 5th, 1820, he visited a coin collection belonging to a canon of the cathedral at Salerno, apparently a visit of no particular significance. A few days later in Naples the Duke of Vargas gave the Prince *some coins from Posidonia, Pestum and Velleja*. A couple of months passed by and then, on May 20th, in Naples again, the Prince and the archaeologist Andrea di Iorio discussed the possibility of purchasing coins from the Greek areas of Magna Graecia – an interest in coins is awakening in the Prince. While staying at the Villa Quisisana at Castellamare outside Naples, he paid a visit to a Captain Schmidt on his ship where he saw numerous coins, *many of which found in the old town of Lesbie on the Tripolitanian coast* – that is, they were from Northern Africa, an area for whose numismatic studies Christian Frederik, a good twenty years later, as King Christian VIII, would be of decisive importance.

The Prince also saw the coin collection belonging to the well-known archaeologist and at that time Royal Agent[9] in Rome, P.O. Brøndsted. It is easy to imagine that Brøndsted – known to have been an unusually charming man – encouraged the Prince's burgeoning interest in numismatics. On September 20th the two gentlemen visited *an exquisite collection of coins* belonging to Francesco Carelli, who was later to become an important supplier of coins to Christian Frederik's collection.

On October 26th the Prince visited Giuseppe Capece Latro, formerly Archbishop of Tarento: *he told me that he would give me his collection of Greek coins*. But, as we know, the Prince instead purchased this prelate's collection of antiquities (see page 22ff.).

Some days later Brøndsted's negotiations led to the Prince's first large

purchase of coins, from Rafaele Gargiulo. The price was 671 ducats, which amounted to more than 2 kg of gold – a considerable sum of money even today. On November 3rd and once again accompanied by Brøndsted, the Prince visited F.M. Avellino's *collections of coins from areas in Magna Graecia*. This was the area – Southern Italy and Sicily – that was to become Christian Frederik's speciality.

The pace quickened from November 12th onwards: a visit to S. Giorgio Spinelli,[10] head of a museum, *to see his coin collection; considerable, coins from many Greek and Italian places, coins of the Roman emperors, almost complete, and family coins, very well arranged according to Gens and family subdivisions, as well as important men in them.* His last numismatic visit while staying at Quisisana took place on November 28th. It was a visit to Michele Arditi, head of the Naples museum, to see his coin collection *and admired its completeness as well as the number of rare coins it contains.*

On the homeward journey, while in Rome, the Prince viewed Brøndsted's own collection on January 23rd, 1821, *and studied the Greek coins.*[11] The collection of the Grand Duke in Florence was studied on April 27th, and here we note the Prince expressing a rather more professional opinion: *In the morning I saw the coins in the Grand Ducal collection, but today only the Greek, Italian and Sicilian ones. The Greek are the most complete, particularly the Syrian and Macedonian kings: those from Magna Graecia and Sicily are incomplete but there are a few rare specimens, among them a beautiful gold coin from Tarento. The collection is fully annotated, also the fakes, which should be removed and the whole collection rearranged. Abbot Zannoni showed us the collection.*[12] After a few days Zannoni paid a return visit to the Prince, and now it was the royal collector's turn to show his coins. After the abbot followed the famed numismatist Dominico Sestini, who visited the Prince's collection on two occasions after which he published his observations in a small booklet.[13] Our picture of the Prince in Florence ends with the two coin enthusiasts repacking the coins for the Prince's onward journey. On reaching Parma, coins were exchanged with the coin cabinet there (May 31st), and in Milan there was again the ritual visit and return visit (June 12th). The homeward journey to Denmark was taken in easy stages, and the route included Paris. Here T.E. Mionnet, of the Cabinet de Médailles, was one of the great names in Greek numismatics, famed among other things for his great coin catalogue.[14] On January 15th, 1822, Mionnet showed the Sicilian coins to the Prince; *among them*

Fig. 1. "Médailles grecques de l'Europe faisant partie du Cabinet d'Antiquités" written by C.T. Falbe. In the second column from the left is a series of abbreviations – "As" is, for example, a reference to Sestini's catalogue of the coins of the Prince.

Fig. 4.
Volterra. Aes grave obverse showing Janus; reverse the Etruscan town name with retrograde inscription. Sylloge 18. All illustrations of coins and medals are 1:1.

Fig. 5-6.
Tarentum. Didrachms. Obverse showing a rider on a horse; reverse a rider on a dolphin. The first acquired from Falbe 1841, and the second at the Wellenheim auction in Vienna 1844. Sylloge 861-862.

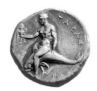

Falbe, a naval officer, began to play a part in the King's collection and Falbe's involvement became considerable over the years. He took over the cataloguing project and a few years later started a new and, as it proved, more definitive catalogue (fig. 1).[17]

It is obvious that the Prince left his mark, which was probably quite frequently guided by aesthetics, on the selection of the Greek coins. Among the geographical areas thoroughly covered by the collection are the Etruscan towns with Volterra in the lead. Otherwise coins from Naples and Tarento in Calabria, and Naxos and Syracuse on Sicily, in addition to the Sicilio-Punic coinages, were obviously attractive to the Prince. Some of these are shown on figs. 4-14.

As the years went by, a truly important collection evolved. But let it be emphasized that the Prince was by no means operating in a coin-cultural vacuum, for Copenhagen provided an environment where knowledgeable archaeologists and numismatists were to be found. Brøndsted played the leading rôle here up until his death in 1842. Falbe and Christian Jürgensen Thomsen, each in their own fields, were also of consequence. Falbe may well have been a rather difficult man and not easy to deal with as a colleague, but because of his excellent contacts abroad – who were no doubt impressed by his close relationship with the King of Denmark – he was able to perform near-miracles. Thomsen was an exceedingly knowledgeable museum man, and the combination of Falbe

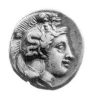

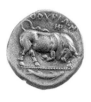

*Fig. 7-8.
Thurium in Lucania.
Staters of silver. Obverse showing Athena with
Scylla on her helmet;
reverse a bull with a
fish beneath. Sylloge
1442-1443.*

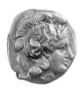

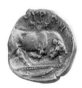

with Thomsen was certainly highly profitable for the development of the collection. Later Thomsen had the invaluable assistance of Ludvig Müller, the youngest member of the Coin Cabinet staff who started work in 1841 without pay but was promoted in the following year and held the position of assistant keeper, on normal terms, from 1847. During the 1850s and 1860s Müller was one of the leading classical numismatists, one might even say the most renowned European scholar in the field of Greek numismatics after 1860.[18]

The great interest in classical numismatics in Copenhagen in the 1830s and 1840s implied that excellent relationships could be forged with coin dealers and enthusiasts abroad. Numerous coins were sent to Denmark by the firm of Rollin in Paris, probably the main supplier to the Danish coin and medal market for a lengthy period of time.[19] The King had first choice, thereafter the Coin Cabinet. This combination of the Prince/King with his private collection and his extremely able advisers who, in the background, managed the public collection – as well as their ability to obtain funds of money seemingly from nowhere – led to the flourishing of both collections.

The driving force behind Christian VIII's impassioned collecting was by no means exclusively a very understandable quest for beauty. He had scientific aspirations as well. Falbe and the somewhat peculiar, brilliant philologist and theologian Jacob Christian Lindberg,[20] had taken it upon themselves to deal with the Punic coinage from Northern Africa in a publication that was to be based upon all the known material – probably one of the earliest of such attempts. The King gave the project his backing in 1842, and a specimen booklet was issued, together with a printed invitation to support the project, and sent out to the whole of the learned world.[21] As so often happens to such projects, both its originators and its patron died long before the work could be published. It was only in 1860-62 that Müller, duly acknowledging the work of the King and his older colleagues, could publish the three-volume *Numismatique de l'Afrique du nord*. The King's involvement in the project is reflected in his diary: *Falbe and Magister Lindberg in the Vase Cabinet, inspected their ranking of the Punic coins; arrangements for their publication are to be made from here.*[22]

A couple of years after the King's death, in 1851, his private coin collection was taken over by the Coin Cabinet to offset various debts of the royal family. This was hardly any surprise to those involved because, as far

as can be judged, there had been some sort of agreement made on this matter. Thus, a year after the King's death, Thomsen noted in an official document that Christian VIII's private collection had been included in the national collection *according to the wishes of the late King.*[23] In the meantime Falbe had died (quite suddenly, in 1849 while he was at work) so Thomsen – but in actual fact Müller – became responsible for the reception of the collection and its gradual amalgamation with the national collection. The King's collection was so overwhelmingly vast that Müller and his successors very largely stopped purchasing anything pertaining to Sicily and Magna Graecia. In fact far more than one hundred years were to pass before there was any appreciable growth in these sectors of the Royal Coin and Medal Collection.[24]

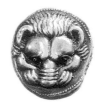

Fig. 9.
Rhegium. Tetradrachm, obverse lion's mask; reverse laurel-wreathed Apollo. Sylloge 1933.

One result of including the King's Greek coins in the Royal Collection of Coins and Medals after 1851 was, of course, a great increase in the number of duplicates. Many of these were purchased by the University Coin Cabinet in Christiania (Oslo). The letters exchanged in the mid 1850s between the heads of the two coin collections – Thomsen and Müller in Copenhagen and A. Holmboe in Christiania – have an extremely business-like stamp. It appears that much of the Greek collection of the University Coin Cabinet must have been transferred to Oslo as a result of the Danish state's acquisition of Christian VIII's coins.[25]

Coins from the two important areas of Italy and Sicily held by the Royal Collection of Coins and Medals – as catalogued in the Greek Sylloge[26] – number, respectively, rather more than 2000 and 1100 coins. Of these, respectively 876 and 475 specimens originate from Christian VIII, that is about 44% and 43%, or in other words almost half.

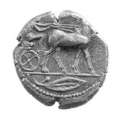
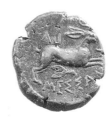

Fig. 10.
Messana. Tetradrachm, obverse a biga drawn by a mule, bearded driver; reverse a hare. The Wellenheim auction, Vienna 1844. Sylloge 396.

Shortly before the second world war, when plans were being made for the great Sylloge covering the Greek coins in the Collection, the decision was taken to start work on the publication in these areas. Here the Copenhagen collection really was of international calibre, and this was proved once and for all. The Collection's management had hopes of obtaining further financial backing for the publication if a start was made with the coins that were of superb quality, also from the artistic viewpoint. In this way the avid collecting of Christian VIII was of great importance for the National Museum of today – because our Greek Sylloge is still one of the most frequently used reference works. To prove this just look in any of the great auction catalogues!

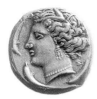

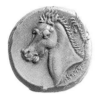

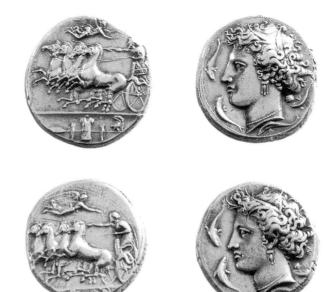

Fig. 13-14.
Sicilian Punic tetradra-
chms. Obverse Perse-
phone (called Tanit in
Carthage); reverse hor-
se's head and date
palm. One acquired
from Bertel Thorvald-
sen, the other from
Santangelo in Naples.
Sylloge 980 and 982.

Fig. 11-12.
Syracuse. Decadrachms. Obverse quadriga, the driver being crowned by Nike; reverse Artemis and
dolphins. One acquired from Santangelo in Naples, and the other acquired in 1844. Sylloge 692
and 693.

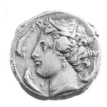

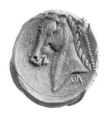

The other numismatic field that fascinated Christian VIII comprised
the medals being struck in his own time. Perhaps this interest was not so
unusual; Thomsen too collected contemporary coins and medals. The
King had been born in 1786 but his interest focused on the French revo-
lution, i.e., the period from 1789 and everything thereafter. Was there, be-
side the absolute monarch, a revolutionary romantic dwelling in the
breast of Christian VIII? And one who remained there right from his
youth to his days' end?

The kindling of the King's interest seems little out of the ordinary. It
was an old tradition in France that the *gloire* of the monarch should be
reflected in the art of the *médailleur*. This was exploited to a very great
extent by both Louis XIV and Louis XV, and even by the revolutionary
governments and Napoleon. Extremely talented and knowledgeable
artists were frequently employed for the work. Napoleon used this pro-
paganda medium to the full. A suitable collection of the Emperor's

medals – but beginning with the storming of the Bastille – would be mounted under glass in small cases and provided with fine gold lettering on the leather binding, whereafter they were used as gifts for princes and other influential individuals. A couple of specimens are preserved in the library of the Collection at the National Museum, but it was only recently discovered that one of them must indeed have been presented by the Emperor Napoleon to the young Prince Christian Frederik. In the inventory, a note by Falbe beside the entries for the medals in the case, records that they lay in the case presented by the Emperor Napoleon.[27] This came into the Prince's possession after Napoleon's marriage to Marie Louise but before the birth of the King of Rome, which must date it around 1810 – just at the start of Christian Frederik's lifelong passion for medals. The Prince built up an enormous collection of medals and coins commemorating the revolution: described by Falbe as pertaining to the French revolution or in some way or other derived from it (fig. 15). The coins originate from France between the years 1789 and 1847, as well as Switzerland, Spain, Latin America and wherever the revolution left its mark.

Already on the Prince's travels in Germany in 1818, when he visited Rothschild the banker in Frankfurt, his interest in medals is apparent. The Rothschild collection was not one purchased by the Prince, but some years later a collection was acquired in Switzerland, and thereafter purchases continue without a break. For instance, the Spanish collection belonging to Christian Giede – a somewhat unusual numismatist, who was the first head of the Athens Museum – was purchased in 1835.[28]

If we imagine that the King's revolutionary streak can be deduced from the contemporary coins and medals in his collection, a couple of small incidents point in this direction too. By 1830-31 Europe was once more engulfed in uprisings, France and Belgium being also implicated, as discussed below. To the east, in Poland, there was an insurrection leading to a revolutionary government. The King's Polish coins relating to this episode were kept in a small separate case, for it would have been highly embarrassing had all visitors seen them – because the Warsaw mint had suddenly given away a well-kept Russian state secret. The Czar had, namely, struck "real" Dutch ducats of Russian gold and with Russian-made dies; however, during the insurrection the Warsaw mint had provided the ducats they struck with a small, discretely placed, Polish

Catalogue

de médailles et monnaies françaises
depuis
la Revolution de 1789

jusqu'à nos jours,

à la suite desquelles sont classées :
Les médailles et monnaies des Princes
et des Etats qui furent élévés ou renversés
pendant cette révolution,

—

successivement recueillies pour
Le Cabinet Archéologique
de
Sa. Majesté Christian VIII.

par Falbe

crowned eagle! It would have been a diplomatic disaster had either the Russian or the Netherlands envoy seen these coins, for which reason they were carefully kept apart. It was only in 1868 that the Russians put an end to this rather bizarre, but seen in the light of history by no means unique practice.

One of the largest groups of medals in Christian VIII's collection is that pertaining to the Belgian revolution of 1830-31. Here are more than a hundred specimens.

In the aftermath of the Napoleonic wars (which came to an end in the Vienna Congress of 1814-15) the southern Netherlands – that is Flanders, Brabant, Liege, etc. – which had earlier belonged to Austria but been annexed by France during the revolutionary wars, was amalgamated with Holland under the Dutch King Wilhelm I. This was a tenuous situation because the northern and southern Netherlands, today Holland and Belgium, were very different in nature. This incompatibility was rooted not only in religion but also in cultural and linguistic factors. Matters came to a head in Brussels in 1830 in an insurrection triggered by a performance of François Auber's opera *La Muette de Portici*.[29] This opera has a duet *Amour sacré de la patrie* that was hailed as a new "Marseillaise", becoming the signal for revolution.

The separation of the two geographical areas, which did not take place without loss of life and in which also Antwerp became Belgian, was a very delicate matter in European politics. To keep the balance of power after the Napoleonic conflicts, it was important that France did not gain a dominating influence on Belgium. Thus a French prince who had been offered the throne of this country had to refuse the honour. Finally, Prince Leopold of Saxony-Coburg-Gotha became king of the Belgians in 1831, taking the name of Leopold I, whereafter he could marry a French princess. A new country appeared on the map of Europe and the balance of power in Europe remained more or less undisturbed until 1848.

Prince Christian Frederik must have been keenly interested in these events. This is the only reason that can be found for his vast collection of Belgian commemorative medals, because only very few can be called beautiful and many are downright ugly. Presumably several of them were struck with a commercial objective in view, but all were obviously acquired for the collection. At first, Christian Frederik himself personally

Fig. 16.
Coins and medals from the Middle Ages and later times, page 7. The page shows a selection of medals from the Belgian revolution 1830-31, among them the one struck to ridicule the Belgian regent Baron Surlet de Chokier.

BELGIQUE.

EXPLICATION
D'UNE
MÉDAILLE

Frappée en l'honneur du RÉGENT de la Belgique, pour perpétuer le souvenir des éminents services qu'il a rendus à la Patrie.

La Médaille représente d'un côté le portrait de ce grand Citoyen sous la forme du Sauveur emportant une brébis grasse sur les épaules, avec la légende

EGO SUM PASTOR BONUS.
Je suis le bon Pasteur.

Dans l'exergue on lit:

E. B.ᴏⁿ SURLET DE CHOKIER
RÉGENT
DE LA BELGIQUE.

Le revers représente la Belgique sous la figure d'un mouton tondu avec la légende:

SIC VOS NON VOBIS VELLERA FERTIS OVES.
C'est ainsi, moutons, que vous ne portez point la toison pour vous.

Dans l'exergue on lit:

VOTÉE AU RÉGENT
AVEC FL.ˢ 10000 DE PENSION
PAR LA PATRIE
RECONNAISSANTE
1831.

purchased 40 specimens in 1831. Later, up until 1844, the faithful Falbe purchased items from Danish auctions and from his foreign contacts. He seems to have set great store by obtaining a complete collection. Here Falbe was assisted by a large printed catalogue covering all the modern Belgian medals.[30]

I am quite convinced that the background for the Prince's special interest in this rather unusual group lay in his own personal experiences in Norway.[31] During this country's short-lived period of independence in 1814 the Danish Prince, who was acting as Governor, had been chosen as king, but the complicated European political situation at the time led, in fact, to the loss of Norway. And what did Christian Frederik gain from all this trouble? Nothing, except a reputation as a rather suspicious character on the European power politics stage, and, as a kind of banishment, an appointment as governor of the Danish island of Funen with residence in the provincial capital of Odense. Of course, I draw this conclusion *e silentio* but it is a fact that Christian Frederik always remained highly sensitive about his Norwegian experience.[32]

The Prince must have followed developments in Belgium for several reasons: this is shown by an unusual bit of evidence found in the catalogue of this part of his collection. In the middle of the catalogue a small printed note has been inserted giving an explanation of a particular medal that had been struck to ridicule the temporary regent of Belgium, Baron Surlet de Chokier. He had been forced to relinquish his position after the king had been chosen but, says the note, this gentleman had been granted a pension of 10 000 francs in recognition of his *services to the fatherland* (fig. 16) – in other words a pretty good remuneration for his efforts. Christian Frederik, of course, had received nothing whatsoever for all that he had done in Norway. Obviously, it would have been impossible for him to complain of his treatment, nor could he have displayed any kind of personal bitterness or sense of injustice. Perhaps, in this very unusual and indirect fashion, the Prince here gave a glimpse of his personal feelings.

This shows that a collection of objects belonging to such an impassioned collector as Christian VIII can give an insight into sentiments which, for diplomatic considerations and strict court etiquette, would normally never have been disclosed.

Today Christian VIII's collection of revolution medallions allows us to

display the bloody battles of the Napoleonic wars in the sublimated form of the medal-maker's art.

Finally, we come to one of the latest and largest groups of medals incorporated into the King's collection, those given to him by the French King Louis Philippe in 1846. As mentioned earlier, there was an old tradition in France of striking medals as royal propaganda disguised as art on a high level. After the July revolution of 1830, Louis Philippe wanted to found a royal dynasty and started to make good use of the possibilities that lay in the art of the medallist. He was able to present no less than 70 silver medals as well as a number of copper ones to the Danish king in 1846. Falbe entered these in the records as *Gift from the King of the French*[33] – which was the formal title of the last king of France. The gift was presented at a time, 1846, when there were close political ties between France and Denmark: for example Christian Frederik had presented the Order of the Elephant – Denmark's highest honour – to Louis Philippe after the French king had survived unharmed one of the many attempts made on his life by assassins.

As far as can be judged, it was the French statesman Élie Louis Decazes, Duke of Glücksbjerg, a man of some importance in Denmark during the reign of Christian VIII, who had prompted Louis Philippe to make this appropriate gift. Perusing the catalogue of the Danish king's collection of French medals, it seems that Decazes was a frequent supplier of items, and perhaps Christian VIII had an exchange arrangement with him.[34] The Frenchman was the only duke in Christian VIII's realm, that is apart from the Glücksborgs and the Augustenborgs. Unusually for a French politician, he had acquired the Danish title of Duke of Glücksbjerg in 1818 in connection with his participation in negotiations after the Napoleonic wars.[35]

These medals illustrate a period that is otherwise not particularly well elucidated. They represent a style and a taste very unlike that of the domestic Danish, showing a marked tendency to overdecoration and pomposity. The time was past when, a generation earlier, the great events of world history had been interpreted to the spectator by elegantly executed figures clad in ancient garb. But the revolution and the Napoleonic era had not been deliberately omitted, for Louis Philippe's gift included suitable specimens of all medals struck since the revolution. It is noteworthy that, even today, the French Monnaie des Médailles, on the Quai

de Conti in Paris, can supply purchasers with coins and medals struck during the last centuries – anybody can go in and purchase copies chosen from the voluminous catalogues.[36]

Louis Philippe's gift is today part of the collection that belonged to Christian VIII and is grouped together with other, generous gifts from France. One is a large collection of jetons that must have been presented to King Christian V by Louis XIV in the 1690s – more than 300 years ago.[37] Taken together, these different objects make up a truly impressive collection of French medals. It should be noted that Louis Philippe's medals are unusually finely struck, so from a purely technical viewpoint too we have quite a unique group.

Probably the Louis Philippe collection has never been shown in its entirety – but a representative selection was displayed in 1998. It arrived in Denmark in 1846 and was thereafter catalogued by Falbe – but just one and a half years later the Danish king had died and the French king had been deposed. A new form of government had come into being in France, and the former royal house was no longer of any interest. These circumstances, and the rather odd design of the medals – differing very greatly from that of both earlier and later specimens – justifies our illustrations (figs. 17-25).

The medals commemorate all the significant events that took place in France during the reign of Louis Philippe from when he took over power during the July revolution and up until the mid-1840s when, it was said, *La France s'ennuye*.

Considering the collection as a whole, it definitely gives a somewhat coarse impression. It seems that the art of the French medallist, previously the best in Europe and again so later on, had run off at a tangent. The medals became larger and thicker than ever before or after. Were the medallists trying out the very boundaries of their art? The technicalities involved in the production of such medals must have been exceedingly demanding; the higher the relief and the thicker the blank, the more difficult it is to strike a medal. These facts are constants that have remained unaltered during the centuries in which medals have been struck in Europe.

As far as can be judged, Christian VIII himself chose the medals making up this large presentation group. When Decazes was planning to visit Denmark, the King quite simply sent him a list of what medals he

Fig. 17.
After the July revolu-
tion in 1830, Louis
Philippe became regent
and later king. Obverse
A. Depaulis; reverse
J.-F. Caunois.

Fig. 18-21.
The reverses of four medals: the reorganisation of the National Guard 1831; new flags for the National Guard 1830; The Spanish Museum, an extension to the Museum of Arts 1834; the Luxor obelisque on the Place de la Concorde 1836. Louis Petit, Gayrard and, for the last two, A. Bovy.

Fig. 22.
The King opens the
Versailles museum
(A toutes les gloires de
France). Reverse and
obverse A. Depaulis
1837.

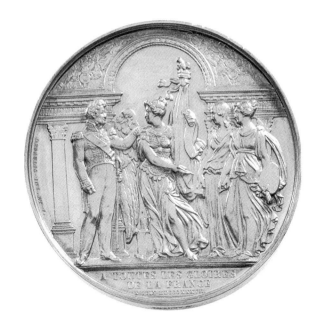

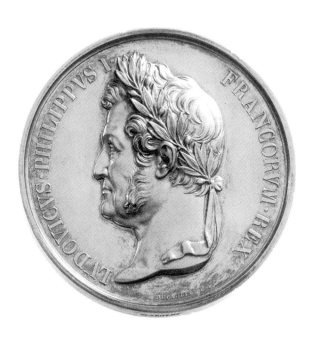

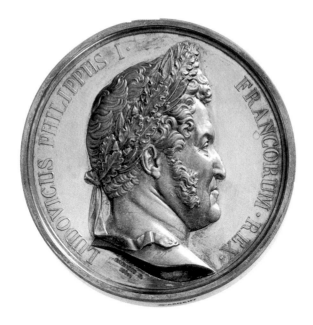

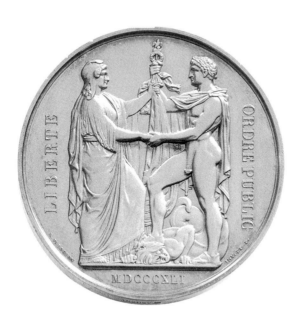

Fig. 23.
Liberty and main-
tenance of public order
1841. Obverse
J.-F. Caunois, reverse
J.-B.E. Farochon.

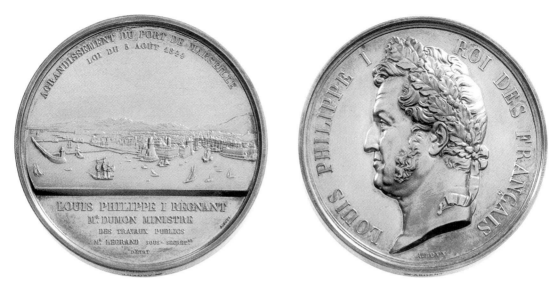

Fig. 24.
Extension of the harbour at Marseilles 1844. Reverse and obverse A. Bovy.

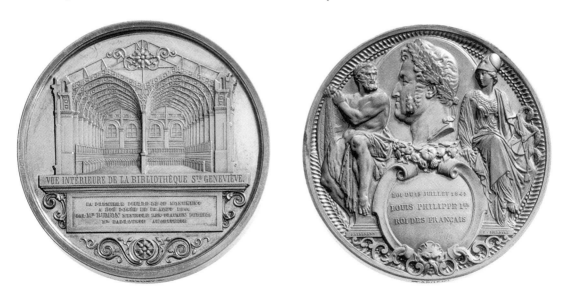

Fig. 25.
Building of the hall at the Sainte-Geneviève library 1844. Reverse unsigned, obverse J.-B. Klagmann.

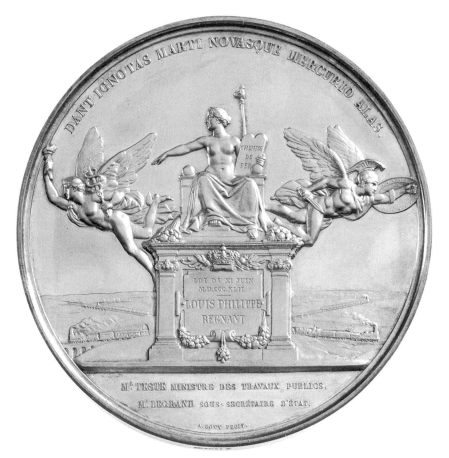

Fig.26.
Law for the construction
of the great railway
lines 1842. Reverse
and obverse A. Bovy.

needed: *List of the medals in silver and bronze, si faire se peut.*[38] Probably De-
cazes had them all with him when he visited Copenhagen a fortnight lat-
er.

The court of Christian VIII gives the impression of being an unusual
mixture of life amongst the aristocrats – Decazes as Duke of Glücksbjerg
was a welcome and popular guest – and yet habits shared with the
Copenhagen bourgeoisie. An entry in the King's diary for an early spring
day in 1845 may serve to illustrate this point: *Took tea in the throne room.
The Landgraves visited and I showed them the French medals.*[39]

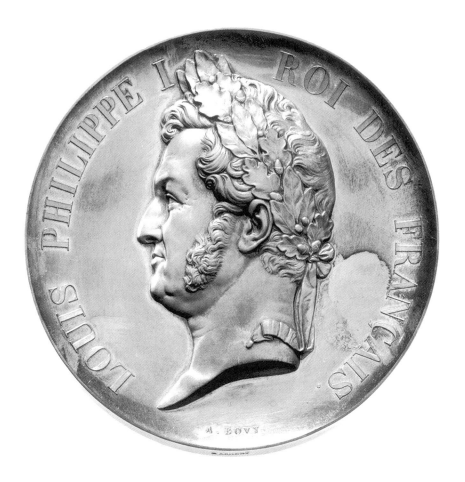

The King's brother-in-law, Landgrave Wilhelm of Hessen-Kassel[40] and his wife, the King's sister Charlotte, saw here a collection of medals reflecting royal views of French history. This, of course, is the primary purpose of striking a medal.

Nonetheless not all the medals from the time of Louis Philippe were included in the 1846 gift. One extremely large silver medallion, struck by Bovy in 1842, was lacking for it had already been acquired (fig. 26). It is one of the largest that we possess and is on permanent display, portrait side uppermost.[41] Today we would probably find the scene on the

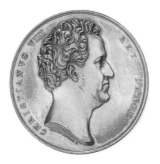

Fig. 29.
Christen Christensen's
Ingenio et arti medal
1841.

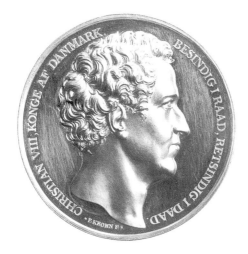

Fig. 30.
The obverse of F.C.
Krohn's medal comme-
morating the death of
Christian VIII 1848.

Christian VIII was genuinely interested in the new medals and in the medallists. When a medal was to be struck in Copenhagen in honour of the German liberal, J.A. v. Itzstein, who was in difficulties in his home-land of Baden, the King personally discussed the details of its design and production with Christen Christensen.[46] Indeed it is correct to say that the art of the medallist in Denmark *had a higher reputation at the time of Christian VIII than ever before or after.*[47] In my opinion, the Golden Age that Copenhagen experienced in the first half of the nineteenth century is

easily discerned in the art of the medallist – and this is first and foremost due to the efforts made by Christian VIII.[48]

A fundamental difference appears between the Danish king and the French king in the medal portraits of Christian VIII made by Christensen and by Krohn (figs. 29-30). The French king is portrayed as large and powerful, and seems increasingly lacking in charm as time goes on. Both kings had a tendency to corpulence in their later years, and whereas this feature is by no means hidden on the French medals, or coins for that matter, Christian VIII liked to be portrayed as he had been in the days of his youth. He was an attractive, charming man, who could well be said to have been the darling of the muses. No one can doubt that the King's passion for collecting made a lasting contribution to the Golden Age of Copenhagen and this gives a special brilliance to our displays of items from his period in the Royal Collection of Coins and Medals. To no one is this more apparent than to those who have the pleasure of working among his beloved coins and medals – of lifting one up and recognizing the familiar monogram of Christian VIII on the label lying beneath it.[49]

Appendix

Catalogues of Christian VIII's coins and medals held by The Royal Collection of Coins and Medals

XVII A 7, folio. The Roman Series of the coin collection of His Royal Highness Prince Christian Frederik. The crowned monogram of Prince Christian Frederik decorates the front of the catalogue. The catalogue contains 1527 items, and appears to have been compiled in 1829-30; continued until 1839. Unpaginated.

XVII A 7, folio. Médailles grecques de l'Europe faisant partie du Cabinet d'Antiquités de Son Altesse Royale le Prince Christian Frederik. Most of the text is by C.T.Falbe; compiled 1832, continued until 1847. 48 + 35 sheets (Fig. 1).

XVII A 7, folio. Médailles grecques de l'Asie et de l'Afrique faisant partie du Cabinet d'Antiquités de Son Altesse Royale le Prince Christian Frederik. Description, *vide supra*. Sheets 35 to 129.

XVIII A 8, folio. Notices pour servir de Catalogue à une suite nombreuse de Médailles anciennes des peuples et des villes. Première partie. The main text by Sestini, important parts of the catalogue are apparently written by Prince Christian Frederik himself. The crowned monogram of the Prince decorates the front of the catalogue. Unpaginated, loose sheets inserted (Fig.3).

XVIII A 9, quarto. Cabinet de Médailles Grecques. IIème Partie de la Sicile et des isles voisines. The crowned monogram of Prince Christian Frederik decorates the front of the catalogue. Most of the text is written by P.O.Brøndsted with additions by the Prince who wrote the concluding remark: *Terminé le 31 Mars 1830*. 95 pages (Fig.2).

XVII B 9, folio. Two volumes of 285 and 250 pages, but the descriptions are sparse. On the front is an inscription in Danish written in golden capitals "Medals and coins from the middle ages and modern time". The catalogue is in French.
Vol.1. Denmark, Germany, Austria.
Vol.2. Netherlands (incl. Belgium), Switzerland, Italy, Russia (Fig.16).

XVII B 10, folio. Catalogue des médailles sur les principaux évènements en France pendant le règne de Louis XIV, ainsi que de Médailles et monnaies françaises depuis 1635 [reference 50 p.77] jusqu'à la Révolution de 1789, successivement récueillies pour le Cabinet archéologique de Sa Majesté Christian VIII. Full binding from the 1840s with the Danish coat of arms and wild men. Inscription in golden capitals in Danish "French medals and coins from the birth of

Louis XIV in 1638 up to the Revolution 1789". Unpaginated.

XVII B 10, folio. Catalogue de médailles et monnaies françaises depuis la Revolution de 1789 jusqu'à nos jours, à la suite desquelles sont classées: Les médailles et monnaies des Princes et des Etats qui furent élévés ou renversés pendant cette révolution, successivement recueillies pour Le Cabinet Archéologique de Sa Majesté Christian VIII par Falbe. Bound as the previous volume with Danish inscription in golden capitals "French medals and coins from the Revolution 1789 up to today". [Reference 51 p.77]. 220 pages (Fig.15).

Notes

1. See for example Steen Jensen 1997, 208.
2. Most of the keepers and assistant keepers working at the Royal Collection of Coins and Medals have dealt with Christian VIII's coins and medals. This applies to Niels Breitenstein, cf. Breitenstein and Schwabacher 1942/1981 10-14; Galster 1967; Mørkholm 1981; Kromann and Steen Jensen 1986; Steen Jensen 1988 and 1989, and Kromann 1991.
3. See Steen Jensen 1981, especially 29-46 and the appendices 87-90.
4. Ramus 1816.
5. No study has been made of Christian Frederik's enormous correspondence in this connection, cf. Helk 1963.
6. See the list in this book, page 74.
7. Acquisition ledgers were introduced only in 1845; the same series are still kept up to date (apart from those used for exchanges).
8. The following builds upon Steen Jensen 1988.
9. At this time there was no senior Danish diplomat accredited to Rome (a consequence of the Reformation that was only rectified under Queen Margrethe II). A royal agent was thus the highest civil servant who could be posted to this city, cf. Marquard 1952, 262.
10. Spinelli was the author of several numismatic works, for instance one on the Cufic coins struck by the Longobards, Normans and Suevi in Southern Italy.
11. Brøndsted's coin collection is still extant because it was later acquired by Bertel Thorvaldsen. This unusual story was related by Mørkholm 1982.
12. Today Zannoni is remembered for a small publication dealing with a coin find from Fiesole 1829.
13. Cf. Kromann 1991.
14. Mionnet 1806-37.
15. At that time the term *medals* was used not only for commemorative medallions but also, quite generally, for ancient coins, cf. the name of the French national collection: Cabinet des Médailles, at the Bibliothèque National de France in Paris.
16. Kromann and Steen Jensen 1986, especially 200.
17. See the list of catalogues of Christian Frederik's coin collections page 74.
18. Mørkholm 1981, 148-156.
19. Cf. remarks on the financial transactions between the cabinets in Copenhagen and Christiania, and Rollin in Paris 1854, Skaare 1992, 72.
20. Kromann and Steen Jensen 1983.
21. Mørkholm 1981, 146-148.
22. Dagbøger IV, 17 December 1842.
23. Galster 1967, 162.
24. Namely the collection of Professor Knud Fabricius, see Mathiesen 1987.
25. See Skaare 1992 – the letters relevant in this connection are from 1854-56, 68-86.
26. Breitenstein 1942.
27. Steen Jensen 1989.
28. Kromann and Steen Jensen 1986, 205; Christian Giede, the first head of the Coin Cabinet in Athens, had an unusual and eventful life, see

Haugsted 1994.

29. The opera had a text by E. Scribe and G. Delavigne, 1828. Performed in Copenhagen in 1830.

30. Guioth 1844; the numbers given in Falbe's catalogue for each individual medal do not however fit this work. Thus it must be assumed that there was another, perhaps older work to which Falbe makes reference.

31. The latest account of this affair is given in Langslet 2000.

32. As late as 1844 Christian VIII wrote that the notification of the enthronement of Oscar I, brought to him by Count Stedingk, carefully avoided *all allusions to Norway … just as* the letter had been *sealed only with the Swedish coat of arms* (Dagbøger IV, 26 Marts 1844). I am indebted to Dr. Anders Monrad Møller for this information.

33. The entry was written in French.

34. *Falbe given coins and medals for Duke Decazes*, Dagbøger IV, 13 Maj 1844.

35. Nørregård 1960, 157.

36. Catalogue général, volume 2.

37. Steen Jensen (ed.) 1987, 22.

38. Dagbøger IV, 4 Juni 1846.

39. Dagbøger IV, 18 Marts 1845.

40. The Landgrave was acting governor of Copenhagen – presumably an honorary title relatively free of duties.

41. Rasmussen 1992, 39, no. 29.

42. The medal is not mentioned in Döry and Kubinszky 1985 because their publication comprises only "Mitteleuropa". They have, however, no corresponding motifs of such great age.

43. Dagbøger IV, 15 Marts 1844.

44. This applies to C.A. Muhle, book-keeper at the Faeroese trading-post in Copenhagen, who cut the stamps for several medals in the 1820s, and C.A. Müller, an archivist in the Office of the General Staff, who ended as postmaster in Randers. He designed medals on the occasion of Frederik VI's homecoming from Vienna 1815 and the crowning of the royal couple.

45. Steen Jensen 1995, 131.

46. Dagbøger IV, 16. marts 1844.

47. Galster 1947, 196.

48. Kromann and Steen Jensen 1996; English translation in Steen Jensen 1999.

49. It is characteristic that most of the large collections acquired in the nineteenth century were not entered in the acquisition ledgers. The task was too difficult and the accession process only completed after a number of years. In the present case a small stamp showing the monogram of Christian VIII was made. This was used to mark the relevant labels so that, thereafter, there has never been any doubt about the provenance of the coins concerned.

50. The number 5 is written with dots, in actual fact the catalogue starts with the year 1638.

51. The list was first published by Galster 1967, 160. Galster counted the contents of each catalogue: 1: 3274 coins, valued [according to Mionnet] at 29,441 francs, 2: 977 coins, valued at 4170 francs, 3: The Republic 322, the Emperors 1527 coins, 4: 118 Danish and 79 German, 5: 319 items, 6: Louis XIV 330, Louis XV 1, Louis XVI 4, various series 74, mainly in bronze, 7: 2773 coins and medals.

What the collections meant to Christian VIII

Anders Monrad Møller

The title of this contribution could just as well be turned around to read: what Christian VIII meant to the various collections of his time. If we did so, however, the result would be purely speculative for there is little concrete evidence to find. Instead, we shall consider the relationship of Prince Christian Frederik, later King Christian VIII, with the collections, as well as his own rôle as a collector. Documentary evidence for this is found almost exclusively in the Prince's diaries and notebooks, now published in their entirety, and thus we shall mainly be dealing with the relatively small world of the King's literary legacy.[1]

Our starting-point, however, lies in some of the earliest letters received by the Prince, giving evidence of his interests and his own collections.[2] His grandmother, the widowed Queen Juliane Marie, wrote as follows to the almost eight-year-old Prince in the summer of 1794: *I am just as pleased as you are, that you may soon expect the presents which you told me about: likewise that your collection of plants and insects is much larger in all respects this year than it was last year, I can well understand that this gives you pleasure; and not least the considerable collection that ..[Mr] Rothe has given you; also that the beautiful Flora Danica has been added to your library.* The letter is signed *your faithful Grandmama.* The next year, another short letter from the faithful Grandmama mentions an Arab gold coin that she had sent him.

Another letter to the young Prince in the same year was from the elderly Ove Høegh-Guldberg, prefect of the Aarhus region and a member of his father's circle. He wrote: *My dear Prince will soon receive from me the collection of different kinds of wood that I promised him. The box containing it was shipped from here yesterday and will soon arrive at Sorgenfrie. The coins will follow later, as soon as I can find time to select them, but I am extremely busy.* Quite correctly, the next letter reads: *My gracious master will by now have*

received his coins, and I feel sure that he will let me know what he is doing with them. Perhaps the Prince did, but his letter to the prefect cannot be found. It is said that Guldberg wished to have all the letters he had received from members of the royal family put in his coffin and buried with him – and his wishes are supposed to have been carried out.

These extracts serve to identify the Prince's interests: natural history on the one hand and numismatics and archaeology on the other. Most boys, of course, make collections of some sort or other but, as we shall see in the following, Christian Frederik continued indefatigably to build up his collections throughout his entire life.

The notes that he wrote in his boyhood, from 1799 to 1803, contain quite a number of brief remarks on his collecting interests. The first was written in February 1799: *Took [money] from my bureau box, to buy minerals, 5 rix-dollars.* The following year he notes that Professor Vahl, botanist, had given him an American mineral, atacamite, which, incidentally, had been called after a place in Chile. In 1801 Hans Christian Knudsen, a renowned actor, had returned from a tour of the provinces (in aid of the wounded and the relatives of the dead after the naval battle of Copenhagen) and had presented some minerals to the Prince. Knudsen was a protégé of Christian Frederik's father, Prince Frederik the Heir Apparent, and perhaps this was his way of reciprocating favours; at all events, he seems to have made generous gifts to the young Prince.[3] In 1803 the Prince notes that he had selected the best of different Icelandic mineral specimens that Knudsen had left him to choose from. And there were several from the Geyser! The Prince's own notes record that he later sent Knudsen a courteous letter, enclosing 100 rix-dollars, in acknowledgement of the gifts he had received, which included an old Icelandic carved horn and several minerals.[4]

The Prince was given a microscope as a Christmas present in 1799, whether to study the minerals, the plants or the insects we do not know, but it could have been used for all three categories of objects. It appears that Christian Frederik went botanizing for the first time on May 26th, 1793, as eight years later, on the same date, he recalled the event in his diary. This was because his younger brother, Ferdinand, was to go botanizing for the first time with the zoologist Hans Severin Holten who taught both boys. It is obvious that the collector's zeal was being exploited for educational purposes. Certainly the Prince's herbarium was

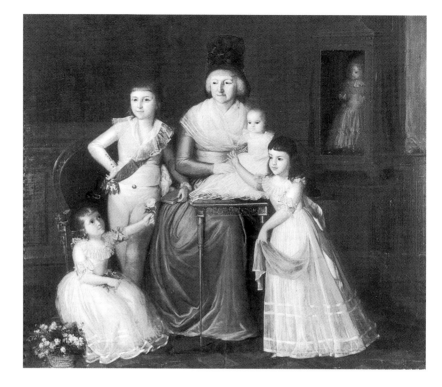

*Fig. 1.
The widowed Queen
Juliane Marie surroun-
ded by her grand-
children – the seven-
year-old Christian
Frederik on the left.
Painting by
J.C.E. Viertel 1793.
Jaegerspris Castle.*

expanding. In 1800 he was given a collection of specimens of Norwe-
gian trees by P.C. Abildgaard, a well known veterinarian. In 1801 the
Danish consul in Tangier, Peter Kofod Ancher Schousboe, who had quite
a reputation as a botanist, gave the Prince a collection comprising no
fewer than 192 Spanish and Moroccan plants, before he left Denmark to
return to his post abroad. Schousboe was one of the many consular offi-
cers who proved of great use to Danish collectors over the years.[5]

Moreover Danish clergymen working abroad were often able to bring
interesting objects back home. In 1802 the Prince paid three visits to the
clergyman Niels Studsgaard Fuglsang, who after working in Tranquebar
had returned to Denmark to be rewarded with a parish in the town of
Slagelse. Fuglsang had returned home with different items pertaining to
natural history, in particular, paintings and plants. In addition, he related
much to the eager Prince about the life and habits of the heathens in the
Far East.[6] With respect to plants, the Prince found that H.C.F. Schu-

macher, an anatomist and surgeon, was worth a visit. There was an extremely interesting collection of skulls to see, in addition to other natural curiosities. Schumacher was also an expert on fungi and the Prince noted: *I saw his insects and a collection of fungi, drawings and descriptions, made by himself, and which would be a great source of knowledge if ever printed.* In fact, little of Schumacher's work was ever published, but what remains is still held by the library of the Botanical Garden in Copenhagen. Schumacher's interests were obviously very similar to those of the Prince, and on a third visit the Prince viewed his new minerals, as well as some of his insects, and also a living monkey.[7]

Several remarks about insects appear in the diaries. Counsellor Niels Tønder Lund, deputy in the General Customs House, was among those who fostered the Prince's interests and, on January 22nd 1800, the Prince noted: *Visited Counsellor Lund, who gave me many pretty insects.* Three years later the two collectors were to meet again on February 22nd. *At midday visited Counsellor T. Lund: he has received some insects from Vienna. The last insects that I received came with the Kiel packet-boat that is lying stuck in the ice.* Later in the same year Lund generously removed a large number of duplicates from his collection and gave them to the Prince.[8]

The most unusual gift of insects came, however, from the Princess of Würtemberg, wife of Duke Frederich of Würtemberg, who was a general serving with the Danish forces. The gift consisted of *two beautiful larvae.* This seems rather surprising, for where on earth could the Princess have obtained these beautiful larvae?[9]

The main numismatist contact in the Prince's boyhood was none other than the extremely learned later bishop of Zealand, Friederich Münter. The Prince saw Münter's collection of medals in 1801, and in the following year Münter viewed the Prince's own collection. It should be noted here that in the Prince's notes *Medal Collection* means, as was normal at this time, both ancient coins and medals of any age.[10]

Minerals, plants, insects, coins and medals – all were collectable objects. In addition, the Prince, of course, visited art exhibitions and showed an interest in both paintings and etchings. He paid numerous visits to the Classen library where, for example, he studied Denon's great work with its etchings from Egypt – Napoleon's Egyptian campaign. Moreover the Prince was always to be seen at the spring exhibition of paintings at the Charlottenborg Palace. After the death of the painter Jens Juel the Prince

viewed his private collection before it was sold at auction, but there were only a couple of pictures that the sixteen-year-old Prince would have liked to possess himself.[11]

There were, of course, educational aspects to these interests and there is no doubt that the young Prince was much influenced by his teachers. His favourite was Niels Iversen Schow, a philologist, and this must have had an effect on the boy's interests. In his notes for 1803, when his actual education was drawing to a close, the Prince wrote: *I consider Schow to be one of the most able men in the sciences, as he is not pedantic and takes a view of the whole, as well as realizing that it is not enough for a prince to be a man of science, he must also be a man of the world.*[12]

The Prince had now reached the stage where he began in earnest to express his own opinions on both the arts and the sciences. This can be seen already in the notes he made during his first, relatively brief journey abroad in 1803. He visited all manner of collections on his travels. In Schwerin there was a cabinet of curiosities, antiquities, and a collection of paintings and other unusual items. Herrenhausen boasted a botanic garden. The Walmoden Palace in Hannover possessed a collection of antiquities. In Böckeburg there was a collection of paintings; but many of the paintings seemed to be heavily restored. At Kassel, the Prince criticized the arrangement of the coin collection. The specimens were arranged *according to subject, with subdivisions according to states and then in sizes, not a good way of doing things.* Finally, in the small principality of Neuwied, a lieutenant showed the Prince many Roman antiquities that he had himself excavated with funds provided by the Princess of Neuwied. They were not of any importance *because the country is impoverished* – commented the Prince.[13]

The Prince's route home took him via Aarhus, where he was shown Guldberg's collection of portraits: *a priceless collection of etchings, that is portraits of men famous in Danish history.* This was a method of collecting that obviously impressed him.[14]

Safely home in Copenhagen again, the Prince paid a visit to the Kunstkammer. He had, of course, been there before, noting e.g. in his diary the previous year the theft of the celebrated golden horns – Denmark's best known antiquities. On the occasion in question, however, the Prince invited Fru Kaas, wife of Frederik Julius Kaas, President of the High Court, and, most importantly, her two daughters to accompany him. It seems

that he had a romantic attachment to young Frederikke Kaas. He described the excursion as follows: *We met as agreed in the morning … in the Kunstkammer , as I had arranged. They were seeing everything for the first time, and in some detail but not exactly always with attention.* No doubt an accurate observation. As regards the Museum, the Prince remarked that it contained, of course, some lumps of gold, the sad remains of the golden horns. There were also some good paintings, but not as good as those he had seen in Kassel. He ended his report with the following remark: *otherwise nothing has changed here.* Hardly a very flattering conclusion.[15]

There are gaps in the diaries for the following years for this was the time that the Prince spent in Norway, when there was much else to fill his mind and time. But, of course, he visited the collections in Trondheim of the Royal Norwegian Society for the Arts and Sciences, of which he was president.[16] By now his critical faculties were well developed and he could evaluate what he saw, often recording his opinions in writing as well. For example, he could not be shown an altarpiece without voicing an opinion. In the Danish town of Kerteminde, for instance, in 1816, he notes in his rather truncated style: *I found the church contains nothing remarkable. The painting on the altarpiece, a second-rate work, is a Judas with a red wig on his black hair.* The Prince makes short work of this visit. If he had had greater iconographical knowledge, he might have found a subtle interpretation for the red hair, but this was not in the Prince's character.[17]

The Prince and his wife made their grand tour from 1819 to 1822. Caroline Amalie's health was the rather thinly disguised excuse for an extension of the journey beyond its originally intended length.

The Prince's diaries reveal that visits to museums and collections took up a very great part of his time abroad, far more in fact than the average traveller on his grand tour would have devoted to such pursuits. At all events, the two parallel diaries that he kept at the time written in French and Danish are faithful records of his experiences.

The Prince's notes indicate that on his travels one of his great interests lay in minerals, and there were reasons for this. Already on the outward journey, travelling south, it appeared that he was in possession of assets that could be put to good use. In Heidelberg, when visiting the mineralogist Professor Leonhard, the Prince recognized two splendid pieces of Iceland spar that he had himself sent to the professor. In Brunswick he met the mineralogist Rippentorp, who promised to supply him with

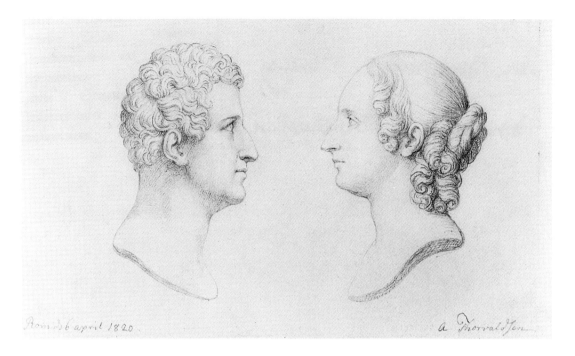

Rom d 6 april 1820. *a. Thorvaldsen*

Fig. 2.
Prince Christian
Frederik and Princess
Caroline Amalie drawn
by Bertel Thorvaldsen
when the royal couple
were in Italy. Hirsch-
sprung Collection,
Copenhagen.

minerals from the Harz area and elsewhere, while the Prince promised to supply him with minerals from the Faroes and Bornholm in exchange. This was the procedure that continued throughout the tour: the Prince received gifts and was able to reciprocate in kind.[18]

The Prince's most important acquaintance in the field of mineralogy was Abbot Teodore Monticelli, who lived in Naples. The two enthusiastic mineral collectors corresponded right up until 1843, two years before the death of Monticelli. Their first meeting took place in January 1820, and the Prince was able to ascertain that the Abbot's collection was quite unique with respect to what he termed *volcanic products*, quite a logical description considering the geography in the vicinity of Naples.[19]

The Prince and Monticelli went on an excursion to Vesuvius, and by chance a small eruption took place on this very day, January 26th, 1820. White and black smoke rose from the volcano, and volcanic products fell to the ground. Monticelli reported that the Prince bravely went up to the edge of the new crater. He was not in the least dismayed by the sudden eruption with its shower of stones that fell at his feet; so unaffected

was he that he even gathered up some of the still smoking stones in his hat and showed them around.[20]

This rather dramatic event was followed up by a somewhat different kind of challenge. On March 17th, 1820, there was a meeting of the Academy of Sciences in Naples and, wrote the Prince: *je prix le courage de lire en français les notizes que j'avais faits sur ma visite au Vésuve ...* It is quite unnecessary to say that, of course, he received high praise for his lecture, and as the proceedings of the Academy appeared in print so too did his contribution that day. On November 5th, Monticelli and two gentlemen from the Academy visited the Prince to present him with 50 offprints of his *notizes*. He must have been proud of the honour – but there is no rose without a thorn. The critical Prince later pointed out to Monticelli several errors that had slipped into the printed version of his lecture. These regrettable lapses must be recalled should one ever come across the probably one and only printed contribution to the study of mineralogy made by a member of the Oldenburg royal dynasty.

Furthermore, in 1823, Monticelli named a 'new' Vesuvian mineral *christianite* after the Prince. Many years later, after the Prince had become Christian VIII and after his anointing ceremony in 1840, he made a tour of the country and reached Altona (at that time part of Denmark) from where he paid a brief visit to his good neighbours in Hamburg. Here he was received at the newly-opened library, and was paid the compliment of being presented with a copy of his article on Vesuvius. This gave him great pleasure.[21]

During the rest of his grand tour, in 1820-1822, travelling through Italy, Switzerland, France and Great Britain, the Prince was able to hand out printed copies of his Vesuvius lecture. Moreover he continued to establish exchange agreements. In Switzerland in 1821 he met a man who was very obviously a kindred spirit: Jacob Samuel Wüttenbach, a clergyman of Bern and, it seems, the founder of mineralogical studies in his home district. The Prince's diary gives a very detailed description of Wüttenbach's involvement with minerals right from his earliest youth. He had started with an interest in insects and plants, the next step had been minerals, in which nobody in his area before him had shown any interest. These were all subjects in which Christian Frederik himself had had a great interest since boyhood.[22]

It seems a matter of course that the Prince took greatest interest in the

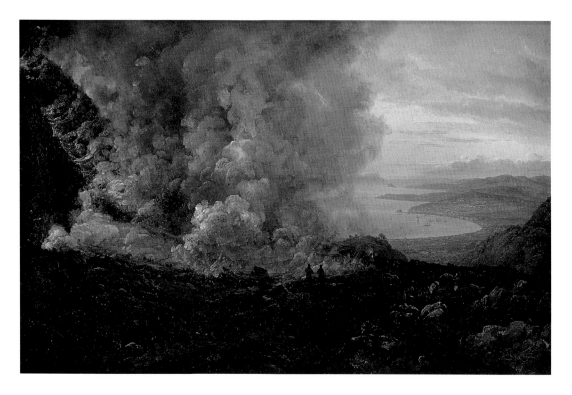

minerals from his own home area, even though we do not know exactly what his collection comprised. He seems surprised when writing of the University collections in Naples: they were kept in *glass-fronted cupboards in a large room, many English and Saxon minerals; the products of Vesuvius are not of greatest interest. Professor Tondi a competent Bessermacher.*[23]

Many are the critical or appreciative observations that the Prince makes on other collections that he visited. In Venice he noted that Count de Rio had a well-arranged and labelled collection of minerals. In Florence, Ottaviano Targioni had the most complete collection of minerals and the largest herbarium to be found in the town. However, there was also the mineral collection at La Specula, which had been very well arranged by Professor Nesti, with Italian, French and German names *written beside each family and crystal shape in metal, all in glass-fronted cabinets and labelled.*[24]

Things were not so well arranged in the natural-history collection of

Magna Graecia and Sicily not complete, but there are a few rare specimens, among them a beautiful gold coin from Tarento. The collection is fully annotated, also the fake coins, which should be removed and the whole collection rearranged. We do not know whether the good folk of Florence ever followed the advice that the Prince gave them in his diary. And what would the owner of a collection in Milan have thought had he known the Prince's private opinion of it? *Quite a complete collection of Greek coins and an extremely messy mix-up of all kinds such as I have never seen before.*[32.]

One notes that the Prince seems to lay great weight on the *completeness* of a collection, both with regard to minerals and to coins. Presumably, for him, completeness meant some kind of representative coverage of a number of types – but on present evidence it is impossible to shed further light on this question.

As mentioned elsewhere in this book, a commemorative medal or medallion was often struck on the occasion of some significant event during the nineteenth century. This was indeed what happened when the Prince visited the Mint in Paris on April 17th, 1822. A medallion commemorating the occasion was quite simply struck on the spot, giving details and date of the royal visit. The Mint must, of course, have been prepared for the Prince; nonetheless the medal was an undeniable expression of the greatest French *courtoisie*. The Prince was given no such honour when he later visited the Royal Mint in London.

Turning to the Prince's archaeological interests, his relationship with the Archbishop of Taranto is given full treatment in the first chapter of this book. Here we shall note that the highly-esteemed prelate was also able to give the Prince a collection of local shells. This was in May 1820; in October of the same year the diary mentions Greek coins that the Archbishop wished to give the Prince.[33]

Archaeology at this time was much influenced by the excavations in progress at Herculaneum and Pompeii, to which the Prince paid several visits. On one of these excursions the royal party passed a spot where there was a splendid view of the countryside. This gave rise to the following description in the diary written in the Prince's terse, staccato style: *view over the Gulf to Naples and to Castelamare and the closest view of Vesuvius in all its awful nakedness; great activity today emitting many red-hot stones and thick smoke.* Much was found "awful" by the romantic travellers of the nineteenth century. And, like them, the Prince could also use the epithet in

Fig. 4.
P.O. Brøndsted – a
lithograph used as the
frontispiece in his
posthumous book
Rejse i Grækenland
published by N.V.
Dorph in 1844.

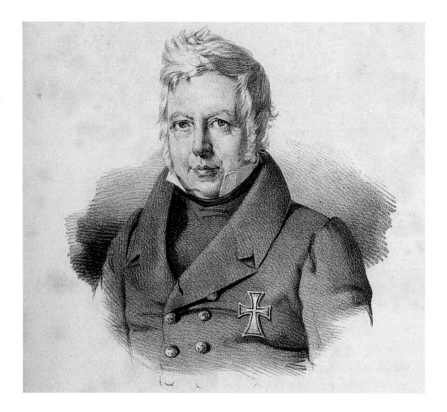

connection with aesthetically pleasing prospects such as the beauty of a waterfall in a ravine, which, for him, was an *awfully beautiful sight*.[34]

Finally, mention must be made of the Prince's innumerable visits to art collections on his travels. His extremely diligent and detailed study of the collections in Florence did not extinguish his own enthusiasm for art – although it nearly did for those who, many years later, published volume II of his diaries and notes. In Naples the Prince made use of a catalogue from 1817, listing several hundred statues and busts – and he actually made comments on every single one from first to last. Such tirelessness forced his twentieth-century publishers to make do at this point with just a note. To share the Prince's opinions we must thus go to the original diaries. In some cases, his deviate from those of the catalogue's author, Finati, and even from those of such a cultural icon as Winckelmann. Indeed there is such a wealth of information in the Prince's diaries on his art

viewing in Italy that what is given in the following must only be regarded as a brief selection.[35]

The Prince paid a couple of visits to Cardinal Fesch's gallery and commented: *many paintings deserve admiration, many are copies or have faked signatures.* Later, commenting on the hanging of the Cardinal's collection, he notes ... *all those showing nudes are kept apart from the others. Rumohr and Dahl accompanied me; the latter has a decisive tone.* The last remark is distinctly enigmatic: can one imagine the Norwegian painter putting the Prince in his place on a matter of aesthetics?[36]

Paris had, of course, much to offer. The Venus de Milo had come to light on the Greek island of Melos in 1820, and the Prince saw the statue in Paris already on November 13th, 1821. Here too he experienced once more something he had first become acquainted with in the Classen library in Copenhagen: *Denon's collections of paintings, bronzes and Chinese objects, Egyptian and Indian rarities.* More than one visit was needed.[37]

It seems as if he met a rather different and perhaps less familiar world when he visited London. After viewing the Somerset House exhibition, he writes with surprise that there was not one history painting worthy of note there. The best portraits were those by Thomas Lawrence. The Prince met this painter later and visited him in his studio. Here he saw Lawrence's series of portraits of generals and statesmen painted to order for the Prince Regent in 1812-1814. *The Emperor Francis, Duke of Wellington, Schwarzenberg are the best, but there is great likeness and spirit in all his pictures.* More could not be said on this occasion.[38]

The Prince's relationship with Danish sculpture was rather like that he enjoyed with medals – he had the opportunity to see much of the art and also to be portrayed in the medium. The great sculptor Thorvaldsen was in Rome at the same time as the Prince, and visits were paid to his studio. Thorvaldsen was seen at work together with his colleague Schadow. Both were modelling a bust of the same highly-admired Albanian girl, and the Prince comments that Thorvaldsen's (bust) was too *ideal*, but Schadow's was the opposite. The royal couple were naturally modelled by the famed sculptor. The Prince makes no comments in his diary on his own bust but reveals a great interest in the busts of his wife. Thorvaldsen modelled her twice. The Prince observed that *the second bust of the Princess is most like her, but is not as beautiful as the first* ... Some degree of idealization was acceptable after all.[39]

The return to Denmark after these years spent abroad must have been rather an anticlimax for the royal couple. They had left in the summer of 1819 and did not return until late in the summer of 1822. Much had happened in Copenhagen in the intervening time, including a spate of bankruptcies in 1820, and consequently many respected trading-houses had been forced out of business. As a whole the 1820s were a time of financial difficulty, and one gets the impression that bright ideas brought back from foreign travel were ill-received for the moment. In addition, it must be recalled that Prince Christian Frederik had little direct political influence at that time. Many years passed before he even became a member of the King's Council. He was expected to attend to his duties as governor of the island of Funen – which, in fact, was just a kind of circumlocution office pushed in between the local and the central administrations. However, he was not obliged to remain in residence in Odense the year round. Reading between the lines in his diaries, it does seem that his life was not all that exciting. When feeling despondent he committed little to writing in his diaries during the sixteen years after 1823 in which he filled in time before taking his place as king of Denmark.

But to go back to the year 1822. Just after the Prince's return to Denmark, he notes on November 12th, 1822: *unpacked some minerals.* On the 15th: *received Counsellor Monrad and showed him the beautiful minerals sent from Heuland in London; he expressed the wish that his collection might one day be united with mine, I did not turn down this idea.* When this did in fact take place at a later date, Monrad's collection contained more than 8000 specimens.[40] The painter J.P. Møller received a visit from the Prince on November 18th. He was invited to see some paintings for which the Prince had recently ordered the frames; these works of art must have been brought back from the Prince's tour.

On March 12th, 1823, the Prince viewed Monrad's mineral collection, and in the following week he once more showed his own minerals to Schumacher and Monrad. But not all those he had ordered had yet arrived for, on March 22nd, 1823, information was received that a box containing minerals had arrived at the Customs House. By now the mineral collection had achieved such proportions that, at the start of the year, it was moved to *the new cabinet,* obviously still in Amalienborg Palace but probably not directly connected with the Prince's own private apartments.[41]

An idea that probably had its origin in the Prince's foreign travels was

that of procuring more space for exhibitions in Copenhagen. Perhaps this had been suggested by Thorvaldsen, but the Prince mentioned it himself several times. Could the greenhouse belonging to the Botanical Garden, situated behind Charlottenborg Palace, be taken over for this purpose? The garden could, of course, be moved elsewhere. This did, in fact, eventually take place but not until 1879.[42]

Another idea being mooted at this time was: could the unfinished Marble Church be completed and taken into use as a museum or glyptothek? The Prince mentions this idea in the summer of 1823, and almost twelve years later G.F. Hetsch produced plans for converting the ruin into a museum of art, but this never materialized and the building was eventually taken into use as a church.[43]

On the other hand, it cost nothing to establish a Society for the Promotion of the Sciences, which still exists to this day. The Prince had become a member of numerous learned societies while travelling abroad. On February 27th, 1824, the diary records that the Prince, together with H.C. Ørsted, Ernst Schimmelmann, J.S. v. Møsting and A.W. Hauch held a preparatory meeting, and later he became an enthusiastic participant in the Society's affairs. He was, moreover, still busily engaged in matters concerning the Academy of Arts.

Innumerable notes concern the Prince's own collections up until he became king. In 1828 he reports that, in future, his private apartment will consist of four rooms on the ground floor of his palace, which necessitated the removal of the Shell Collection to the pavilion. This would have been one of the palace's smaller side buildings.[44]

Hence there was obviously both a Mineral and a Shell Cabinet at Amalienborg Palace, and both appear repeatedly in the diaries in the following years: January 30th, 1830: *Worked in the Shell Collection;* January 19th, 1831: *Count Yoldi in the Shell Cabinet:* November 18th, 1832: *In the Mineral Cabinet with Count Vargas;* February 5th, 1833: *In the Mineral Cabinet* – for instance.

However, during the 1830s, the Cabinet receiving far and away the greatest attention was the Vase Cabinet. In the diaries it seems surprising that the Prince noted so carefully that he left one room, his study, to enter another – adjoining – room, the Vase Cabinet. One can only conclude that this implied that he went to carry out work on his collections, in other words that this was a serious occupation.

Fig. 5.
Christian VIII in his
study at Amalienborg
Palace. The King's
archaeological collection
can be seen through the
open door in the
background. Lithograph
after a drawing by
A. Juul.

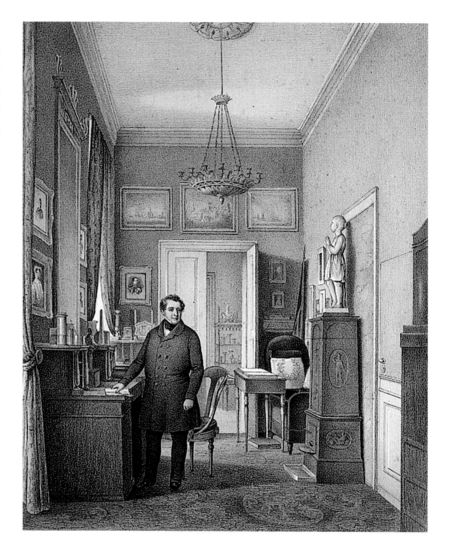

It would be fairly meaningless to make any statistical analyses based on
the diaries, because, not unnaturally, their contents depend entirely on a
variety of factors, including the writer's moods. Nevertheless, a plain cal-
culation reveals that the Vase Cabinet is mentioned six times in 1832,
eighteen times in 1833, seventeen times in 1834. In contrast, the Medal
Cabinet, Coin Cabinet, or Medal Collection is mentioned only four

times during the same period of time. This seems rather odd, for where were the cabinets containing his coins?

It is obvious that the Vase Cabinet was the venue for most events connected with the Prince's passion for his collections.[45] February 4th, 1831: *Counsellor Thomsen in the Vase Cabinet.* June 13th, 1832: *Falbe in the Vase Cabinet, he brought French medals and antiquities.* June 27th, the same year: *Falbe and Thomsen in the Vase Cabinet.* June 4th, 1833 : *in the Vase Cabinet with Counsellor C.J. Thomsen.*

Surely these gentlemen cannot have spent the whole time looking at vases? There is proof of other activities in the diary entry for January 3rd, 1834: *in the Vase Cabinet and saw Schousboe's medals from Tangier.* January 8th, 1835: *In the Vase Cabinet*, where the Crown Prince, Brøndsted, and Thomsen valued Schousboe's Arab gold coins. Finally, for November 11th, 1835, we read: *In the Vase Cabinet, received French and English medals via Henriques.*

There seems no doubt that it was in the Vase Cabinet that Christian Frederik did his own work on the collections, and here he received his closest members of staff when dealing with the coins, and other matters too. In 1834 it was to the Vase Cabinet that *Professor Finn Magnussen brought his interpretation of the Runamo inscription* (in fact a wildly inaccurate interpretation). And in 1835 Brøndsted came to the Vase Cabinet to show the Prince *views from a journey to Greece* made by the German painter Baron Stackelberg.[46]

After he became King, Christian Frederik had in principle greater scope for involving himself with the public collections. For example, the diary reveals that the feelings of C.F.L.T. Rumohr were badly hurt when he was not appointed head of the Print Collection. Moreover, the King took an active interest in the affairs of the Royal Coin Cabinet at Rosenborg where, he records, Professor Justus Olshausen *"read"* the Persian coins. Later there are notes on the cataloguing being carried out there.[47]

The King makes a few notes on matters concerning the royal collections of paintings. The landscape painter, Professor Møller, had been trained as a conservator and in the mid-1840s he was working on the history paintings of Jürgen Ovens, a painter of the Baroque period, who had lived in Holstein. On June 2nd, 1845, the King inspected the fully restored works in the Christiansborg gallery where it was suggested to him that the paintings, which had been removed from Schleswig-Holstein, should remain in Copenhagen. But, no, the King maintained that these

Gottorp paintings belonged, of course, to Gottorp Castle. In the long term, though, his wishes went unfulfilled because, as far as we know, most of them are found today in Frederiksborg Castle, Hillerød.

Those in charge of the collections at Frederiksborg Castle were, however, favoured with some royal guidelines when the King was staying at the castle together with C.J. Thomsen and Professor Møller in 1842. The diary reports: *Explained the basic rule to Thomsen and Møller that, in the collection of historical portraits, likeness is the main issue, the value of the painting subordinate. Copies are not to be included in the collection but could be hung in the rooms on the fourth floor.* This statement speaks for itself.[48]

However, the diaries record considerably less about the King's own collections than they did earlier in his life. Not one is mentioned in the year 1840, for example. Later they reappear but not with their former frequency. There was much to occupy the King, who first and foremost attended to his duties as ruler of Denmark. His astonishing diligence in this respect is well recorded in his diaries and notes.

On the other hand his accession did imply that the Amalienborg collections now appeared on occasion in Denmark's official yearbook. There is mention, for example, of the *Special Mineral Collection* with Count Vargas Bedemar as Keeper. Further, the *Special Zoological Collection* with Henrich Beck as Keeper and Lieutenant J.E. Steenfeldt as draughtsman. The latter collection was, of course, identical with the Shell Cabinet, and the Lieutenant was largely employed on drawings for a vast work to be published on shells. Heim, a zylographer, was to produce the plates – twelve each year – the prints thereafter to be coloured by hand. These plans were made early in 1846. Sadly, however, this publication was just one of several projects initiated in the lifetime of Christian VIII but never completed.[49]

The Vase Cabinet was still by far the most frequently mentioned collection in the diaries, and now at long last it was put on an official footing in 1847 by the appointment of Christian Tuxen Falbe as its director. It was called the *Special Archaeological Collection* in the yearbook. This change of status for the collection occurred at a very late date in the reign of the last absolute monarch of Denmark. Christian VIII died early in the next year, and thereafter great changes were made in a great many things, as described elsewhere in this book.

Christian VIII's last connection with his beloved Vase Cabinet strikes a melancholy note. The royal bedroom was not very large so, on January

them virtually identical with the traditional perception of ancient Egypt. The great numbers of these figures that have been preserved, and their modest size, meant that they found their way to Europe at an early date. The earliest known specimen in a Danish collection dates from 1642 and was included in the famed *Museum Wormianum*.[18]

Three of Christian VIII's figures were in the group left unlisted by Falbe. Among them is the largest of the six figures, decorated with ten lines of hieroglyphs (fig. 2), as well as two figures with an identical inscription (fig. 3). Unfortunately we do not know how the King acquired these objects. In 1860-61 two small shabti figures were received from the Queen Dowager Caroline Amalie (fig. 3). These are the only objects donated to the museum by Christian VIII's widow and were presumably left over from the King's collection, or perhaps a later gift (souvenirs?) to the royal family. The last shabti figure belonging to the King (fig. 3), was among the items that he procured from Christian Hansen, the architect. Greece was second home to Hansen and here he lived and worked for most of his life.[19] A portrait of Hansen, by Wilhelm Marstrand, reveals the sitter's enthusiasm for collecting as also his connection with Christian VIII. In the background is a very significant object: a Greek vase.[20]

Hansen also gave the King a well preserved limestone fragment with painted relief, of high quality (fig. 4). This shows a seated figure and has been part of a hieroglyphic wall decoration.[21] Taken out of its original context and purchased in Athens, this fragment is an example of the vast number of architectural bits and pieces found in Egyptian collections all over the world today. Fragments showing representations of the human body have always been in high demand.

The largest item in the King's collection is a painted wooden figure more than 60 cm tall (fig. 5), which he was given by the philologist Peter Forchhammer, who went on a extensive journey in 1838-40, arriving in Egypt in 1839. Here, like so many others of his time, he acquired an Egyptian antiquity that he later presented to Christian Frederik. Peter Forchhammer was a professor in Kiel and spent most of his life in Schleswig-Holstein but he was no stranger to Copenhagen. He was in close contact with Christian VIII and had his support when, in the 1840s, he set up a collection of antiquities at the university of Kiel. This figure appears in Falbe's inventory, under the heading *Oggetti Egiziaci*,[22] as a *Figurina feminile* in painted wood, and reference is made to its mummiform

Fig. 2.
Shabti figure of high quality. Faience. The figure holds a hoe in each hand.

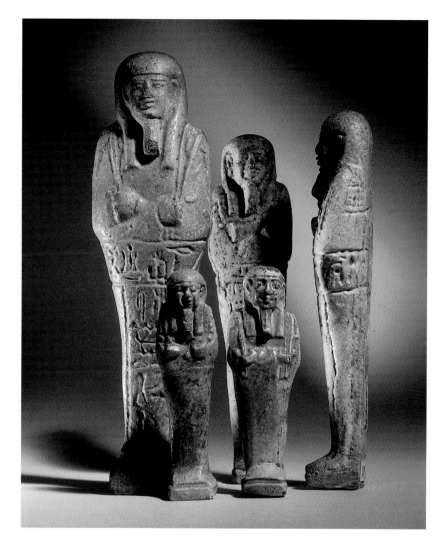

appearance and its connection to the grave, *la Sepultura*. This is a special type of funerary figure popular in the Late Period and representing the god Ptah-Sokar-Osiris, who was associated with rebirth.[23] It is interesting to note that Falbe considered the figure to be that of a woman, which reveals that he had no knowledge of the Egyptian deity concerned.[24] A scrap of paper accompanying the figure reveals that it was found at

Sakkara in a 50-60 foot deep shaft grave in 1839. If this information is correct, it then constitutes one of the most accurate and detailed find records for any object in the older part of the Egyptian collection in the National Museum.[25]

Baron Carl von Rumohr, a German-Danish art lover, who frequent-

*Fig. 5.
Ptah-Sokar-Osiris
figure. In the base is a
small compartment
containing remains of
linen. Traces of text-
bands on both front
and back.*

ed the Danish museums and collections, gave Christian Frederik *an unopened Egyptian document wrapped in strips of cloth and closed with its own seal.* This object is termed *a rarity*. Today it cannot be identified with any certainty but the description raises doubts about the authenticity of the document. The Museum possesses several fake papyrus rolls, some having bits of genuine papyrus and others – more imaginatively – cloth strips wound around wooden sticks. These were presumably made in the early nineteenth century and sold to eager European purchasers, who would have found a rare document specially tempting at a time when the hieroglyphs were still shrouded in the mysteries of deciphering.[26]

Christian VIII was given 34 small Egyptian objects by a certain Georg Booth. The records reveal that this gentleman collected them in Egypt and then presented them to the King.[27] First is *an eye that seems to belong to a figure* (fig. 6).[28] It is an inlay from a mummy-case, carved in a stone of two colours, in layers of slate and limestone. Bits of mummy cases were

Fig. 7.
*Amulets from mummy
wrappings. Stone and
faience. 1.8 - 4.4 cm.*

typical Egyptian souvenirs, and the National Museum keeps a number of fragments containing inlays, stucco decorations and, in particular, entire faces from mummy cases. Because complete mummies and cases would have been difficult to transport, an attractive fragment provided a good solution to these difficulties. Of the mummies themselves, hands, heads and feet were particularly popular.[29]

A large part of Booth's gift consisted of amulets. In ancient Egypt these were used, among other purposes, for burials, when large numbers were tucked into the mummy wrappings. To the amulets were ascribed various symbolic significances that could benefit and protect the deceased.

Of the amulets supposed to give power and strength to the deceased, Christian VIII's collection includes an uraeus, a papyrus column, a cartouche, a feathered crown, three so-called *djed* columns, a *pesesh-kef* amulet (a ritual instrument) and a plummet.[30] Two amulets represent

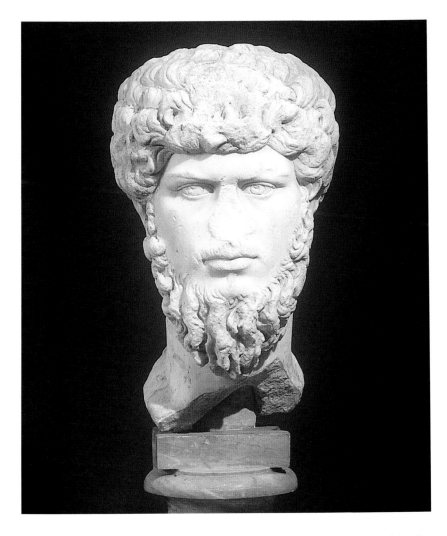

The symbolic value of the gift for donor and recipient originated in the fact that Falbe had brought the bust to Denmark from Tunisia, where he had been Danish consul-general from 1821 to 1832. It was during this span of time that Falbe had come to the attention of the Prince as a result of their common interest in archaeology and numismatics. After Falbe's return to Denmark, he became a pivotal figure in the establishment of the Prince's Vase Cabinet – the name the Prince himself gene-

rally used for his collection of antiquities although it also contained objects other than vases.[4]

Christian Frederik's enthusiasm for Mediterranean archaeology[5] was typical of his time. The later eighteenth and the first half of the nineteenth century were saturated in an interest in classical antiquity.[6] Originally this had been aroused by the excavations at Pompeii and Herculaneum, and then enhanced by the rich finds from the Etruscan and South Italian graves. It became fashionable for the upper classes to collect antiquities,[7] but this was a costly pursuit especially if one lived far from the shores of the Mediterranean.[8] For those fortunate enough to belong to the very wealthiest of the aristocracy, it was easier to purchase antiquities while making the virtually obligatory grand tour to the south.[9] In general, however, collectors were forced to make use of the services of local agents to find their treasures, and it is against this background that we should view Falbe's role as an agent for Prince Christian Frederik in Tunisia, Greece and France – at any rate at the start of their collaboration.[10]

CONSUL-GENERAL FALBE IN TUNISIA

On being appointed Denmark's consul-general in Tunis, Falbe had left the Danish navy with the rank of captain. Together with his wife Clara, he arrived at his post in August 1821. Clara, who was ten years younger than her husband, bore a daughter in 1822, another in 1824 and a son in 1828. It was scarcely a coincidence that the boy was christened Christian Frederik. At this time Tunisia was officially part of the Ottoman empire and associated with the Orient, both in culture and in religion. Compared to Copenhagen, conditions in Tunis, the capital city, were undoubtedly very primitive and it was probably this factor that led to the recruitment of former naval officers for the consular service. They were felt to be men of the right stamp for this kind of assignment – but some thought differently. Rudolph Bay, working as secretary at the Danish legation in Algiers, wrote in 1818 that such officers were: *the most arrogant race of people in my fatherland.*[11]

At this time Denmark had few ships trading with the North African countries[12] so work was no burden in the consulate. In the circumstances Falbe must have welcomed a letter from Friederich Münter, bishop of Zealand and a scholar learned in the fields of theology, philology, archae-

ology and several others as well.[13] Among the information he required was a first-hand account of ancient Carthage, whose ruins lay near the town of Tunis. At the same time he asked Falbe to collect antiquities and coins for the Royal Art Museum in Copenhagen. This museum had taken over the role of the earlier "Kunstkammer" closed in 1821.[14]

Falbe threw himself eagerly into the task of procuring antiquities – often in hot competition with agents from other European countries having the same objectives in view.[15] This was only a beginning though. In 1824 he received a letter from Prince Christian Frederik, whom Falbe had met very briefly in Norway some ten years earlier: *It has pleased me to hear that you are employed in finding antiquities and collecting coins. In this respect one can do no better than follow the advice of our learned bishop, and the ruins of ancient Carthage are a rich and extensive hunting ground. A study of these is an extremely meritorious task. Objects from any epoch of Antiquity are always of value in a collection and in the hand of the knowledgeable scholar. I advise you to take the opportunity to collect [objects] and then to ship them home by means of the first royal vessel appearing in the Mediterranean. In time, I hope, you will also oblige me by sending something for my collection of vases, ancient lamps and Greek and Punic coins ...[17]*

Falbe replied very swiftly: *Although I was certain that Your Royal Highness would applaud my feeble and rather unskilled efforts to be of use to the study of Antiquity, I was far from imagining that they would afford me a renewed and hence extremely precious proof of Your Royal Highness's grace and favour. – Before I received Bishop Münter's request to send the lamps, etc., that I had collected to the Kunstkammer, they were already underway and I presume they soon will arrive. Your Royal Highness will find only rather ordinary objects in this shipment ... I hope to be able to send more interesting ones as I get to know them better ... A few lamps, bowls and small vases that I possess in addition to those already shipped home, and which are less simple and ordinary, are reserved for Your Royal Highness when I am fortunate enough to come home ...[18]* The shipment in question, which contained 288 clay pots, oil lamps, unguentaria and glass arrived in Copenhagen in 1824.[19] These objects were, as mentioned, intended for the Art Museum, and it has proved impossible to trace the *less simple and ordinary* antiquities that Falbe promised to present to the Prince.[20]

Falbe was on leave in Copenhagen[21] from 1828 to 1830 and it was at the beginning of this period that Christian Frederik asked Falbe to work

Fig. 2.
Grave finds from
Thapsus in Tunisia
(Chr. VIII 376, 553,
563, 708 and
ABb 98).

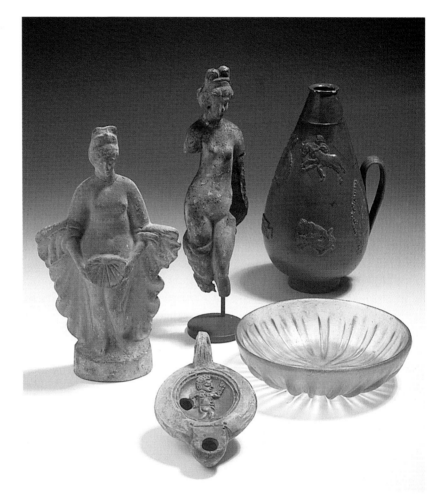

for him in the Vase Cabinet.[22] Much against Falbe's will, he had to spend the two following years in Tunis, and this time without his family. Nonetheless he made good use of his time and succeeded in finding some interesting antiquities, grave finds from ancient Thapsus, which, as far as we can judge, were the first that he presented to the Prince: an African Red Slip jug with relief decoration, a bowl of ribbed glass, a terracotta figure[25] and an oil lamp[26] (fig. 2). Other items were a terracotta figure[27] and an oil lamp[28] from Leptis Minus, a glass bottle from Aquilar–

ia, i.e., El Haouaria,[29] four oil lamps from Bizerta,[30] two from Herqla[31] and Sousse[32] respectively, and a glass bottle from Tunis.[33]

Falbe's greatest achievement on this tour of duty was, however, his making of the first accurate map of the Carthage area. This was published in Paris in 1833 and immediately brought him an international reputation that has lived on until today.[34]

TWO YEARS IN GREECE

In 1833 Falbe was appointed Danish consul-general in Greece[35] and, as a leaving present, the Prince gave him *a diamond brooch valued at 100 specie Dalers.*[36] This might well have been in recognition of the – presumably – unpaid work that Falbe had carried out in the Vase Cabinet.

He hoped to have opportunities for finding many antiquities for the Prince in Greece, but this proved easier said than done. He explained the situation in a letter written just before he set out on a journey to the Peloponnese with Ludwig Ross, conservator for the scientific institutes and antiquities of the Greek Department of Antiquities:[37] *I cannot expect to obtain any antiquities on this journey because he [Ross] wishes to keep everything for the state. This zeal cannot be tempered by my persuasive arguments ... I hope ... that my present modesty and deference to the needs of the state may stand me in good stead when I, in time, might wish to acquire something really valuable that they hold in duplicate in the state collections.*[38] On his return Falbe wrote: *My trip to Tripolitza and Mistra gave so little result that it is hardly worth reporting upon. Anything in the way of an antiquity was requisitioned by Dr Ross on behalf of the government. The government traces all antiquities and makes such great demands that all private individuals must hand over objects to the State Museum that is to be set up, and the officials have orders to reserve everything that is found so that there is very little prospect of obtaining any marbles, inscriptions, vases or bronzes.* Ross, who came from Holstein, wrote in his memoirs that Falbe was talented and a skilled numismatist but also *very self-satisfied, as are almost all the Danes.*[40]

In spite of these restrictions, Falbe was still able to acquire some antiquities in Greece, and even the trip to the Peloponnese was not entirely worthless. At any rate quite a few objects that he must have acquired on this tour were later presented to Christian Frederik: fragments of a grave relief[41] and an inscription[42] from Tegea, a fragment of a sculpture[43] and a piece of an inscription from Tripoli[44] (fig. 3), as well as two frag-

ments of inscriptions from Sparta.[45] Probably he also travelled to Epidaurus, which is given as provenance for two pottery finds[46] and a glass bottle,[47] and also to Aegina from where some ceramics,[48] an oil lamp,[49] a grave relief[50] and a fragment of sculpture originate.[51] Neither is it impossible that he visited the Cycladean island of Seriphos in 1834. At all events he procured different objects from there: pottery[52] and oil lamps from different periods[53] (fig. 4), a terracotta figure[54] and some bronzes[55] (fig. 5).

Athens provided pottery,[56] an oil lamp,[57] a terracotta figure,[58] a pre-Myceneaen arm-ring[59] and two jumping-weights of lead.[60] The most interesting find, from our point of view, is described as follows in the inventory: *Foot of a horse with hoof of excellent workmanship. Now made up of three pieces, the old bronze nails fixed with lead solder, for fastening this foot to the figure, can still be seen. This fragment was obtained by Falbe in Athens. It was found on the Acropolis, near the Parthenon temple and is supposed to belong to*

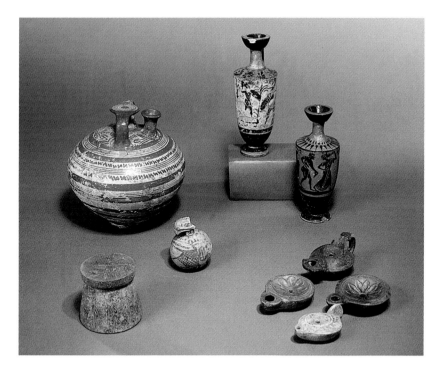

Fig. 4.
Pottery and oil lamps
from the Cycladic
island of Seriphos.
(Chr. VIII 383, 387,
418, 438, 577, 581,
588, 589 and 631).

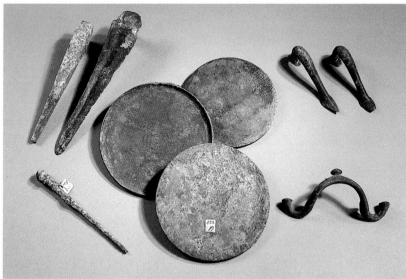

Fig. 5.
Bronzes from the
Cycladic island of
Seriphos (ABa 267-
269, 283-286, 341-
343).

Fig. 6.
A fragment of sculpture:
lower part of left
hind-leg of a horse, or
centaur, found near the
Parthenon, on the
Acropolis in Athens
(ABb 130).

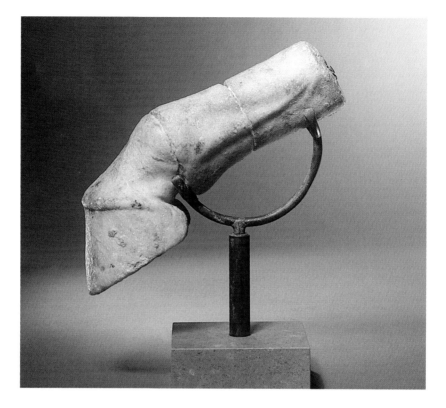

one of the centaurs on the metopes[61] (fig. 6). It is reasonable to consider this fragment as originating from the Parthenon, one of the great achievements – although perhaps somewhat overrated – of Greek art and architecture.

Falbe was recalled to Denmark in the spring of 1835.[62] On March 11th that year Christian Frederik noted in his diary: *In the Vase Cabinet, unpacked a box of antiquities and coins from Falbe ...*[63] – very probably the objects mentioned above.

COPENHAGEN AND NORTH AFRICA 1835-1838

Back in Denmark, Falbe was again active in the Prince's Vase Cabinet, where he provided all the exhibits with serial numbers,[64] and at the same time drew up the first catalogue of the 948 numbered items in the collection: *Catalogo della Raccolta di Vasi Italico-Greci di S.A.R. il Principe Cris-*

tiano Federigo, classificata per diversità delle forme dalla Medisma Sua Altezze Reale, which was completed in March 1836.[65] The best of the vases – arranged according to shapes – are described first. Then follow the oil-lamps, glass, objects of marble, *Vasi ordinarii, greci e romani,* terracottas, architectural fragments, jewels of gold and gems as well as Egyptiana and metal objects. In most cases the provenance and earlier owner are given.[66] The title page shows that the Prince himself was involved in the classification and it was perhaps his wish that the text should be in Italian, although there is hardly any doubt that Falbe was the mainstay of the project.

When P.O. Brøndsted, the archaeologist, was to hold lectures at the University in the autumn of 1836 on the *Fired-clay vases of the Hellenes* and wished to borrow *some vase or other* for use in his tuition, he naturally applied to Falbe for help. Falbe would not, however, lend any item from the royal collection without obtaining the Prince's permission. One of Brøndsted's letters shows that a few *older and knowledgeable men* – among them the 45-year-old Falbe – attended the series of lectures, and that the participants paid several study visits to the Vase Cabinet so that *the best among my audience could become familiar with some of the most superb original vases that are available*[69] – the earliest-known instance in Denmark of Greek pottery being used as a teaching aid.[70]

In the spring of 1837 Falbe was granted 1000 specie Dalers from *Fonden ad usos publicos* for a study tour to North Africa, and Christian Frederik gave him credit for a further 2000 francs.[71] On his way to Algeria Falbe broke his journey, as usual, in Paris where he attended the auction of the unique antiquities, particularly vases, from Vulci in Etruria,[72] belonging to Lucien Bonaparte, Prince of Canino. Prices were extremely high but he succeeded in obtaining four very important vases. The first purchase was a Black-figure amphora made in Athens around the middle of the sixth century BC (fig. 7).[73]

Falbe's journey to Tunisia, via Algeria, proved very eventful and he kept the Prince informed of its vicissitudes in a stream of letters: about the excavations he initiated at Carthage,[74] and about a long excursion he made through Tunisia's still relatively unknown interior, where he visited numerous ancient towns and recorded much of archaeological interest.[75] All these efforts did not result in the acquisition of many antiquities, but Falbe later sent Christian Frederik a drawing of the object cho-

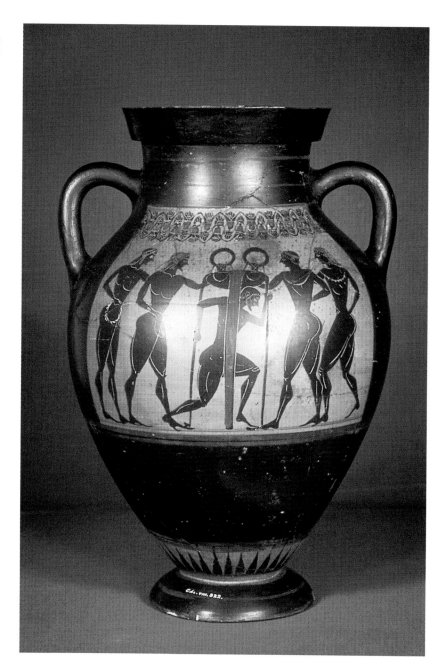

Fig. 7.
Black-figure amphora
made in Athens around
550 BC, showing a
victorious athlete.
(Chr. VIII 322).

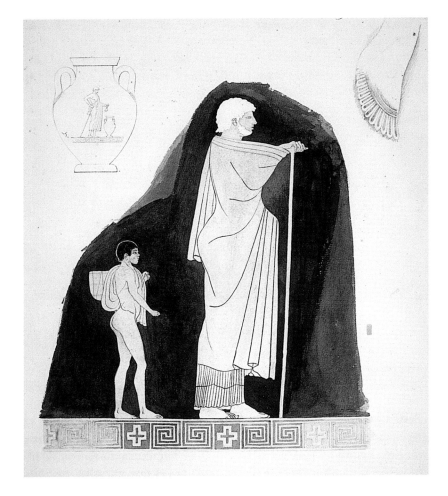

Fig. 10.
Coloured drawing of
the representation on
the Copenhagen
Painter's amphora
– from the proposed
publication of Christian
VIII's Vase Cabinet.
(Chr. VIII 320).

he had received instructions proved highly fortunate for when instruc-
tions did eventually arrive, it appeared that the Prince had not intended
to bid for anything at all.[87]

A letter of 12th December, 1838, from Falbe's wife Clara to Christian
Frederik shows how hard his lengthy absence was for his family. She
writes that there is nothing that Falbe wishes more than to return to
Copenhagen and work for the Prince, *and he would then certainly regain his
health and happiness which have, sadly, been quite broken down by the troubles
of the past year* – if the Prince finds employment for him. *The children and*

I would be certain of keeping him among us if he had permanent employment and a position in this town, and then we could face the future without anxiety, for the future appears very bleak for us, should he again start on his travels. Your Royal Highness must believe that there is no happiness in always living apart from one's family, and although I have hitherto made efforts to ensure that the upbringing of my children should not suffer from his absence, I feel, particularly in the case of the boys, that it is not as it would be if their father was here: not to mention the grief it is for us to miss such a good-natured, instructive and patient man. Clara had no success with her appeal at first.

The situation did not improve until the turn of the year 1839/1840. By then Frederik VI had died (in December) and Christian Frederik had succeeded him on the throne. The new King was quick to mediate between Falbe and Dinesen[88] and wrote, on March 7th, as follows to Paris: *... I expect you ... to return before long. Fortunately the situation is such that you may now without unpleasantness devote yourself to family pleasures, and from me you may expect a warm welcome. I would ask you, to begin with, to start work again where you left off on my collections ...* And, added the King, the reunion would be even more welcome if Falbe brought with him a selection of coins from Rollin, the Parisian dealer.

WORK ON THE ROYAL COLLECTIONS

After succeeding to the throne, Christian VIII was unable to spend as much time as earlier in the Vase Cabinet, but Falbe got to work immediately.[89] In a letter to the King written in July 1840 he requests, *most humbly: Your Majesty's wishes regarding the following tasks that I should like to carry out during Your Majesty's absence in the provinces, namely: ... The Greek vases which have been acquired for Your Majesty's Cabinet in the last three years, have not yet been described or catalogued. I should like to carry out this task and then to display the vases in their correct places in the cabinets. However, as the cabinets with glass doors are too small, and there are too few of them for the many valuable vases which the collection already possesses, and as it presumably will steadily increase, I most humbly suggest that glass doors be made for the two cabinets between the windows and that the latticework cabinets on the floor be provided with glass. This is because the vases displayed in these cabinets have suffered much damage in the twelve years that I have known the collection, and will continue to suffer from the dust and thus the more frequent cleaning to which they will be subjected, and which the most costly vases, which now in part must be dis-*

Fig. 11.
Ground-floor plan of
Christian VIII's palace
at Amalienborg. The
Vase Collection was
housed in room 19,
which adjoined the
King's private apart-
ment, rooms 20-21,
and the throne room,
room 18.

played here, should be spared. Anyone working in a museum will immediately recognize problems of cataloguing, lack of space and cabinet displays. In the library of our Department are two monumental cabinets that are called the Christian VIII cabinets. They must have been provided with glass doors already when they were made so cannot be identical with those mentioned in this letter, but it is possible that they were originally intended for the Amalienborg collection.[90]

The Vase Cabinet was housed in a square room, at the corner, on the ground floor of Christian VIII's palace in the Amalienborg complex. This room lay between the throne room and the King's private suite (fig. 11).[91] All we know of Falbe's rules for displaying objects is that he disliked the vases standing too close together, and that in 1847 he complained of an acute lack of space implying *that the systematic arrangement which alone can adorn a Cabinet and emphasize its constituent parts for correct appreciation, will have to be entirely disregarded unless all accession comes to a standstill: something that would imply decline or disintegration.*[92] A visit to the roughly contemporary display of Greek pottery in cabinets designed by M.G. Bindesbøll at Thorvaldsen's Museum gives some idea of how Christian VIII's vases may have been displayed.[93]

Fig. 12.
Falbe the civil servant,
painted by J.B. van der
Holst in 1844.
Privately owned.

NEW TASKS

On Brøndsted's death, in 1842, Falbe was instructed to participate in the management of the Royal Coin and Medal Collection at Rosenborg Castle[94] (fig. 12). He soon took the initiative to publish, in French, all the known North African coinages, an ambitious project on which he was employed until his death, and which he carried out together with Jacob Christian Lindberg, theologian and numismatist.[95] This association with

the Coin Collection did not imply that Falbe gave up his work in the Vase Cabinet. In fact, his activities there seem to have increased. In the winter of 1843/44 *His Majesty gave his bronzes and different marble objects to the Museum, on condition that the few vases in the Royal Art Museum were transferred to his own private Cabinet.*[96] After this exchange, Falbe re-numbered the Vase Cabinet collection over again.[97] Then he drew up a new *Inventory of Christian VIII's collection of antiquities* – on this occasion with his own name on the title page although the system employed was largely that of the earlier catalogue. First were listed the vases according to shape, thereafter glass, oil lamps, *Vasi ordinarissimi, dai tempi di scadenza dell'arte*, terracotta figures, marble objects, architectural fragments, loom weights and the like, lead sling-stones, vase fragments, objects of gold and silver, gems and finally bronzes.[98] Once again the language is Italian and only the most important items are described in any detail, but in all cas-

Fig. 14.
Silver figure of a
winged eros, holding a
goose. Found in
Sheitla, Tunisia.
(Aba 553).

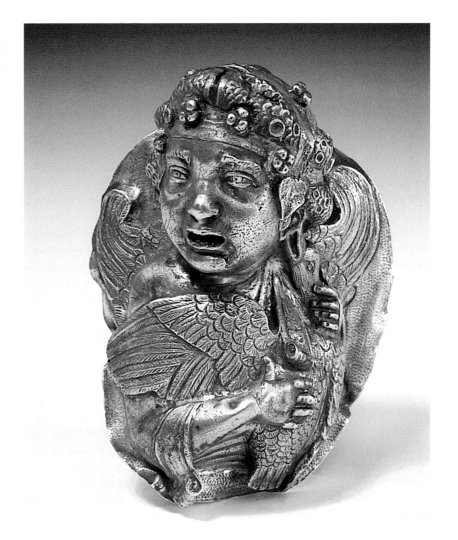

es where known the provenance and earlier owner are given – sometimes accompanied by a small outline sketch. As a key to the main catalogue he drew up a summary *List of King Christian VIII's Antiquities*, where all 1021 objects are given according to inventory number (fig. 13).

Falbe continued his habit of presenting antiquities to Christian VIII on the monarch's birthday, although he had fewer and fewer of these left to

give away. A silver, winged Eros, from Sbeitla (fig. 14),[99] given to the King in 1843, was one of the last relics of his time as consul-general in Tunisia, and in 1846 he had to pass on an Attic Black-figure amphora from the sixth century BC[100] and a Campanian guttus,[101] which he had himself been given by Giovanni Pietro Campana, who had excavated them in the Etruscan town of Caere.

Falbe no longer travelled outside Denmark himself but was deeply involved in the acquisition of several important objects handled by others – for example, the young philologist and archaeologist Johan Louis Ussing,[102] who travelled in Italy and Greece in 1845. Falbe had asked him to look out for a Panathenaic amphora, and Ussing was fortunate enough to find one in Rome, from the end of the sixth century BC.[103] Falbe authorized its purchase and wrote to Christian VIII that its cost was 100 Scudi, or 540 Francs, but *in Paris similar pieces sell for 600 Francs*. He was also involved in the acquisition of more than 200 ancient vases, terracotta figures and bronzes that Christian Hansen, the architect, had collected in Athens.[104]

Falbe was appointed director of the King's Special Archaeological Cabinet at Amalienborg in 1847 and in December of the same year Christian VIII approved his proposal for: *the publication of two instalments of illustrations of the most remarkable (from the artistic and archaeological viewpoint) vases and clay vessels in my collection of ancient vases, with accompanying text provided by Mr Ussing, Master of Arts.* With this objective in view, a start was made on illustrating the vases, and a number of original coloured plates for this planned work are still kept in the archives of our Department. But the publication never saw the light of day. Christian VIII's sudden illness and death in January 1848 put an end to the project.

The death of the King must have been a sad blow for Falbe, who himself died on July 19th, 1849 (fig. 15), shortly after the passing in June of the Constitution bringing to an end the absolute monarchy in Denmark. In 1851 Christian VIII's Vase Cabinet became the property of the nation,[105] and two years later it was amalgamated with the Mediterranean antiquities from the Royal Art Museum, in an epoch-making new display devised by Christian Jürgensen Thomsen: this was the Cabinet of Antiquities in the Prince's Palace – the forerunner of the Collection of Classical and Near Eastern Antiquities in the National Museum today.[106]

Fig. 15.
Portrait of Falbe on his
gravestone in Holmen's
Churchyard – made by
G.C. Freund.

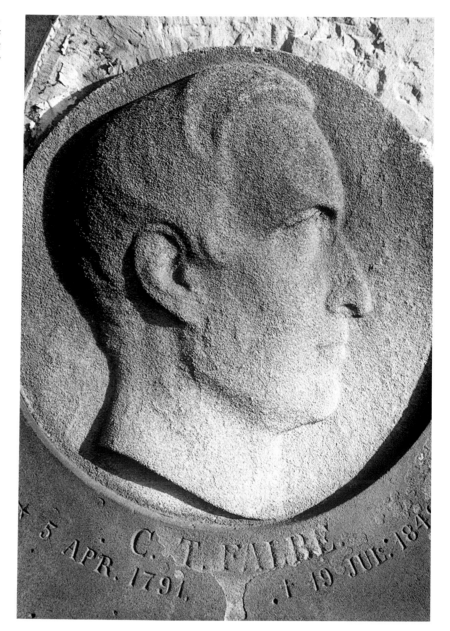

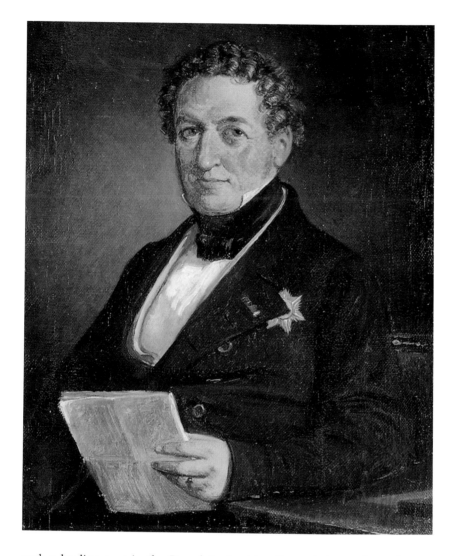

Fig. 1.
Christian VIII.
Painting by J. V. Gertner
1848. Jaegerspris
Castle.

such a leading part in the Royal Antiquities Commission, whose Secretary Thomsen became in 1816.[8]

The first decades of the nineteenth century were the formative years for both young men. Both travelled. The Prince had made plans for travelling at an early age but private and political matters meant that his grand tour proper only started in 1818. He travelled to Germany, Italy,

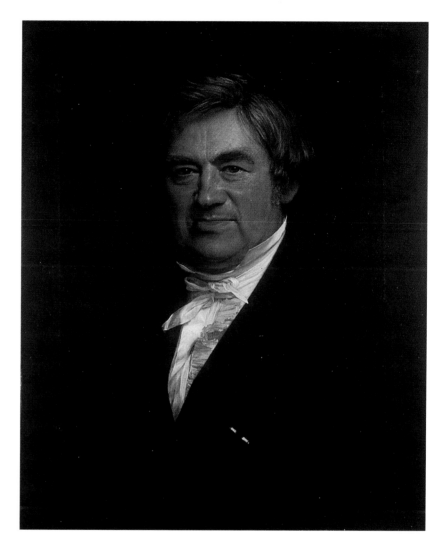

Switzerland, France and Britain and experienced archaeological excavations for the first time. During these three years of journeying the Prince came more closely into contact with the archaeologist P.O. Brøndsted, and he acquired his first collection of Classical antiquities through his purchase of the collection of Capece Latro, former archbishop of Taranto (described in greater detail elsewhere in this publication).[9]

Thomsen's cultural journeys took place within Denmark. His diaries give an impression of his interest in paintings. He visited the great country houses with private collections where he sought out information that could improve his knowledge and appreciation of art. Already at an early age he had become a collector. In 1808, when only twenty years of age, he had purchased his first painting, and he soon established a collection of paintings, drawings and etchings that grew to considerable size over the years.

In 1816 Thomsen was appointed Secretary to the Royal Antiquities Commission, whose own collections were housed in the attic of the Trinitatis church, behind the Round Tower in Copenhagen. While working for the Commission, Thomsen came into close contact with the same scholars who were advisers to the Prince. Bishop Münter is mentioned above; another was Professor Børge Thorlacius, who was closely connected with the Prince's collection in the 1820s.

It was now that Thomsen also became a friend and patron of the painter Johan Christian Dahl, who in turn became closely associated with the Prince while they both were in Italy in 1820. In the early decades of the nineteenth century both Prince and Commission Secretary were finding their places as patrons of young artists, particularly the painters. The Prince was much involved through his position as president of the Royal Academy of Fine Arts (from 1808), and in 1814 this institution was given a new charter enabling it to establish a school to train artists, as well as a society for disseminating good taste in the arts – quite in the spirit of the times and of the Prince himself. The Prince's work in the Foundation *ad Usus publicos* implied that he was also involved in the practice – developed in the last years of the absolute monarchy – of providing funds for young scholars and artists to study abroad and enhance their scholastic or artistic abilities.[10]

In spite of the large difference in their social backgrounds, the Prince and Christian Jürgensen Thomsen did in fact develop along much the same lines during this period of time, but we do not know on what occasion they first came into contact with each other. Several times it seems that Prince Christian Frederik, as worried father of the unruly Prince Frederik (later to become King Frederik VII), called upon Thomsen's assistance. The first was in 1829 when the Prince asked Thomsen to help the young Prince with an archaeological excavation.[11]